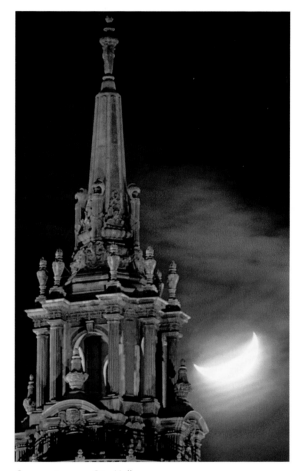

Crescent moon, City Hall

MYSTICAL
SAN FRANCISCO

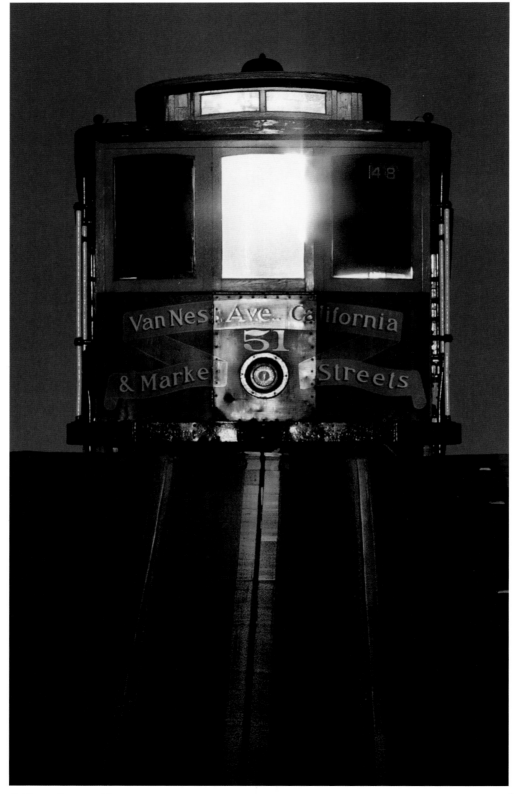

California Street, cable car

MYSTICAL SAN FRANCISCO

PHOTOGRAPHY BY FREDERIC LARSON

TEXT BY HERB CAEN

FOREWORD BY PHIL BRONSTEIN

The San Francisco Chronicle Press

Russell Yip, 1997

HERB CAEN

"I am seriously in love with my city," *San Francisco Chronicle* columnist Herb Caen said on the day he won a special Pulitzer Prize in April 1996. Then he went back to work on his column. "Pulitzer Prize-winning columnist," he wrote. "Well, it does have a certain ring to it. And it will definitely add a touch of class to the obituary." The obituary came on February 3, 1997, after Caen had written more than 16,000 daily columns, to which readers were seriously addicted for sixty years. A promenade along the city's waterfront was named for him, and San Franciscans still celebrate his birthday.

Caen was born in Sacramento on April 3, 1916, and wrote his first column for his school newspaper. He worked as a reporter for the old *Sacramento Union* before joining *The San Francisco Chronicle* at age twenty. During World War II, he served in the Army Air Corps with others destined for fame — Ernest Hemingway, Walter Cronkite and William Saroyan. Then he returned to *The Chronicle*, where he was known for his three-dot style — a staccato, stream-of-consciousness format. Many of his Sunday columns, though, were longer essays describing the incomparable beauty and uniqueness of the city. It is from those essays that the quotes in this book were taken. Caen loved his city unconditionally, "every curve, every nook, every cranny." He liked to look at San Francisco as if it were "a house of cards: postcards set in glowing colors against the hills." He would have enjoyed this book.

John Storey, 2005

FREDERIC LARSON

Frederic Larson has been a photojournalist at *The San Francisco Chronicle* for more than twenty-five years, covering all manner of assignments, from fires to football, earthquakes to celebrities. In 2005, he was sent to Sri Lanka to photograph survivors of the devastating tsunami. His documentary work on the struggles of Hiroshima and Nagasaki survivors more than forty years after the atomic bombs were dropped there made him a Pulitzer Prize finalist in 1988, and his work on the children of San Francisco's Tenderloin and Haight-Ashbury districts earned him other honors. In addition to several other awards, he has twice been named California Press Photographer of the Year, and his work has been included in ten books.

Documentary photojournalism is Larson's passion. But it is his intimate photos of nature — particularly of the sun, moon, and fog — at play with San Francisco's monuments and icons that have captivated readers for years. His awe-inspiring photographs of sunrises and sunsets are instantly recognizable, and many *Chronicle* readers contact the newspaper to buy prints of his work.

Larson was born in Milwaukee in 1949 and was raised near Chicago. He served six years in the U.S. Naval Reserve, was stationed in the Bay Area, and decided to stay there. He graduated from San Francisco State University in 1975 with a degree in radio and television journalism and became a freelance photographer for United Press International in San Francisco before joining *The Chronicle's* staff in 1979. Larson lives in Mill Valley.

MYSTICAL SAN FRANCISCO

Editor	Narda Zacchino
Art Director	Nanette Bisher
Associate Editors	Heidi Swillinger
	Jay Johnson
Designer	Dorothy Yule
Photo Editor	Kathleen Hennessy
Copy Editors	Vicky Elliott
	Geoff Link
	Jennifer Thelen
Business Director	Dickson Louie
Production	Brad Zucroff

SAN FRANCISCO CHRONICLE

Publisher	Frank Vega
Editor	Phil Bronstein

Library of Congress control number 2005927448

International standard book number 0-9760880-9-6

THE SAN FRANCISCO CHRONICLE PRESS

901 Mission Street I San Francisco, California I 94103

www.sfchroniclepress.com

To purchase photographs, please email

larsonphotos@sfchronicle.com

Distributed by Sterling Publishing Co., Inc.

Printed and bound in China, first printing August 2005

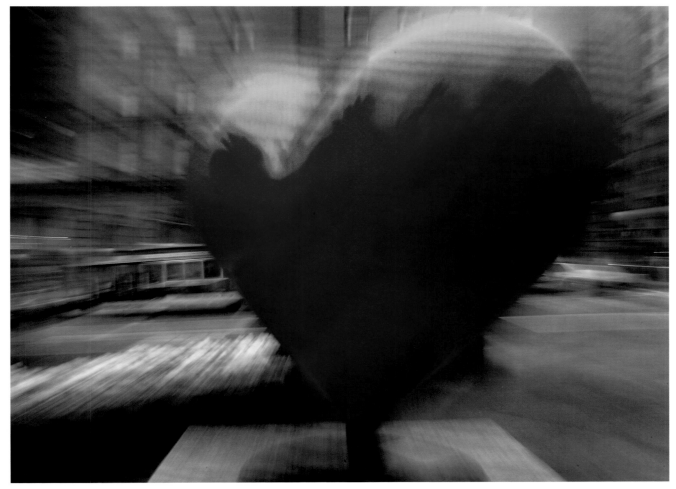

Hearts in San Francisco project sculpture, Union Square

THIS BOOK IS DEDICATED TO MY BROTHERS,

STEVE AND BOB

Frederic Larson

"Thankgawd we're all living in San Francisco.
I'd hate to be this annoyed anywhere else."

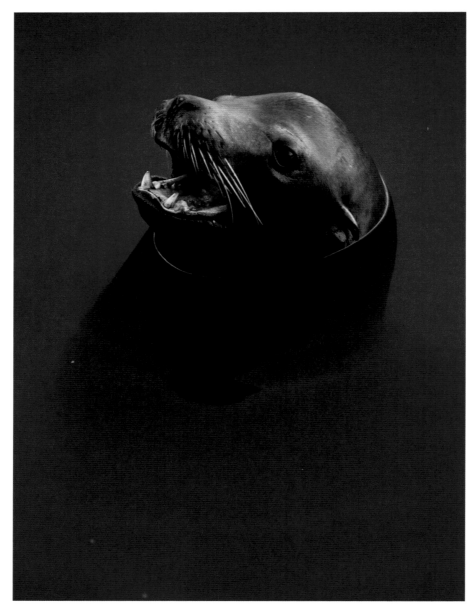

Sea lion, Fisherman's Wharf

FOREWORD

nly a compelling mix of the best photographs and words can paint a definitive portrait of the magic that is San Francisco. It is a city that lives both in the real world and in a mystical realm of beauty and seduction, occupying a special place in hearts around the globe.

For six decades, *San Francisco Chronicle* columnist Herb Caen captured the city's uniqueness, reminding us every day why it is exciting to live in this place of mythic allure. In a sense, Herb fictionalized the city, not by making things up but by weaving its characters, its charm, and its vitality into a tapestry of tales that made the place and its residents larger than life.

Herb was our spokesman, our artist, our poet laureate of the streets. He relished and knew intimately the alleyways and back rooms, the seats of power and the shoe-leather workers, the hustlers and the swells. And he understood, until the day he died in 1997, that they were part of something larger, surrounded by enduring structures and by unparalleled gifts of nature.

San Francisco Chronicle photographer Frederic Larson also has that keen eye for signature views of the city, which he has been capturing with his lens for more than twenty-five years. In his brilliant images, Fred, like Herb, has shown his passion for the city. Whether up before dawn, or out long after midnight, Fred has stalked those fleeting seconds when the moon, the fog, the sun, or drops of rain come together with the city's monuments and icons to evoke the overpowering romance of the city.

"It became an obsession," Fred says of his determination to be in exactly the right place at the right time for the right shot. "Great moments and great light" were key. But it was the city that provided the incomparable backdrop.

Herb, who called Fred "the moon guy" for his hypnotic photos of the full moon over the city, shared with his colleague a long love affair with San Francisco. We hope *Mystical San Francisco* spurs your imagination and dreams as the city did theirs.

Phil Bronstein, Editor, *San Francisco Chronicle*

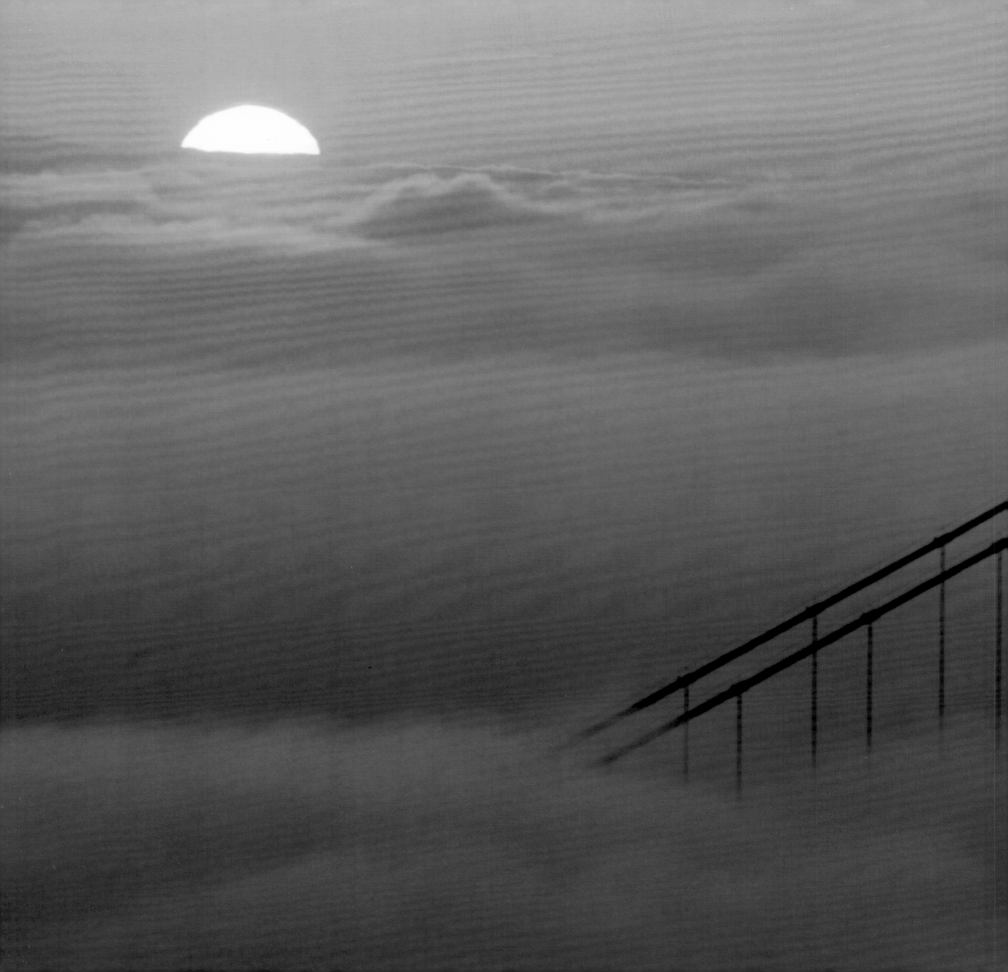

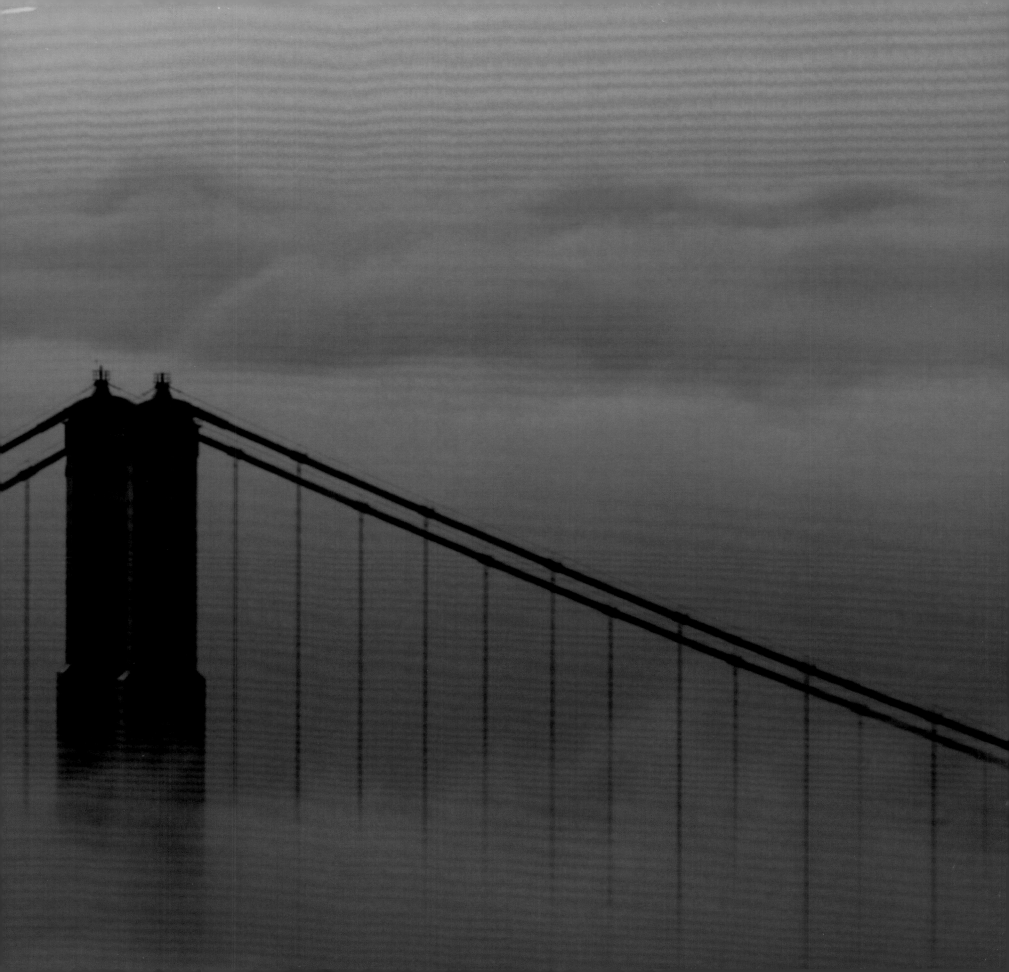

"The mystical structure, with its perfect amalgam of delicacy and power,
exerts an uncanny effect. Its efficiency cannot conceal the artistry."

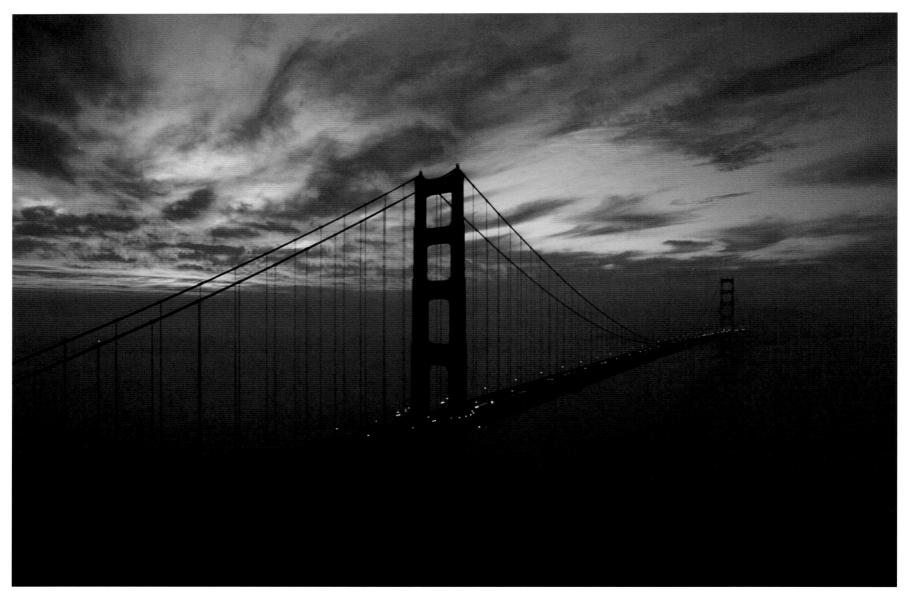

Sunrise, Golden Gate Bridge

Previous page: Sunrise, Marin Headlands

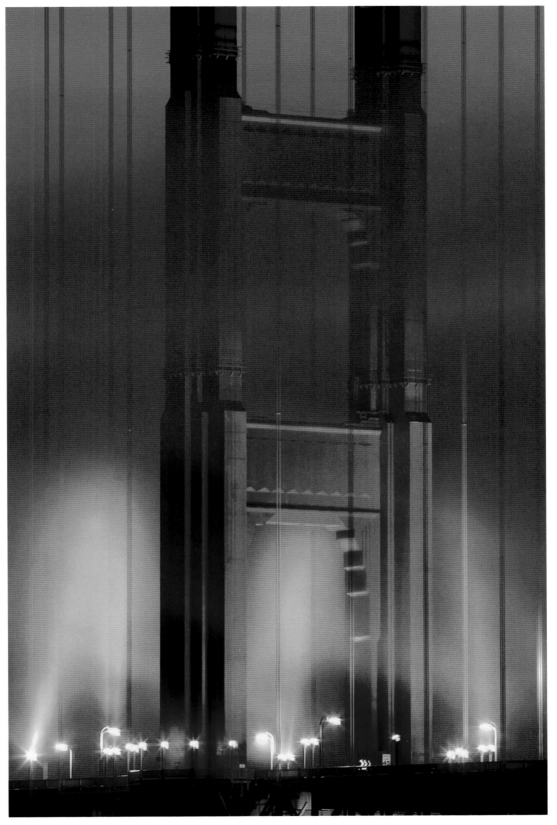

Foggy night, Golden Gate Bridge

"We can also forget those people, mainly newcomers, who say as though for the first time, 'Why isn't the Golden Gate Bridge painted gold?' These people really think that's a clever idea, even though any painter could tell them different. International Orange was a masterstroke."

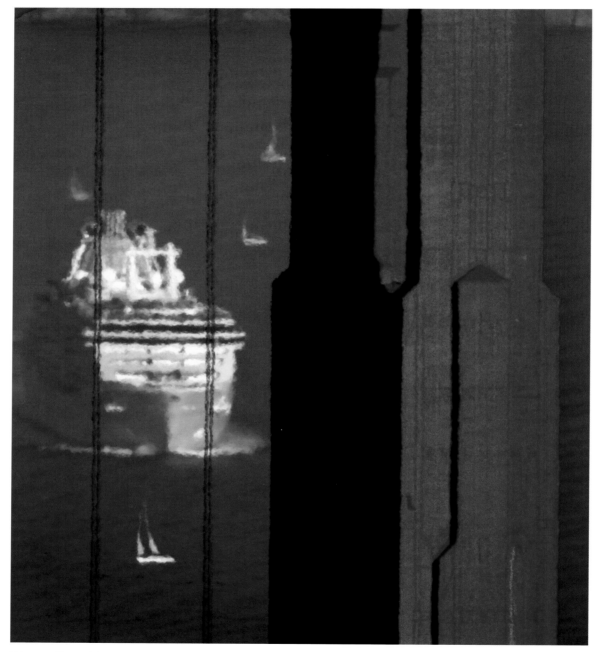

Water traffic, Golden Gate Bridge

"A big city where the small things still count."

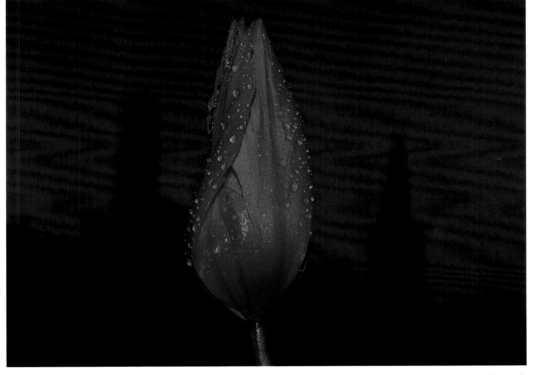

Tulip, Pier 39

Next page: Sunrise, North Beach

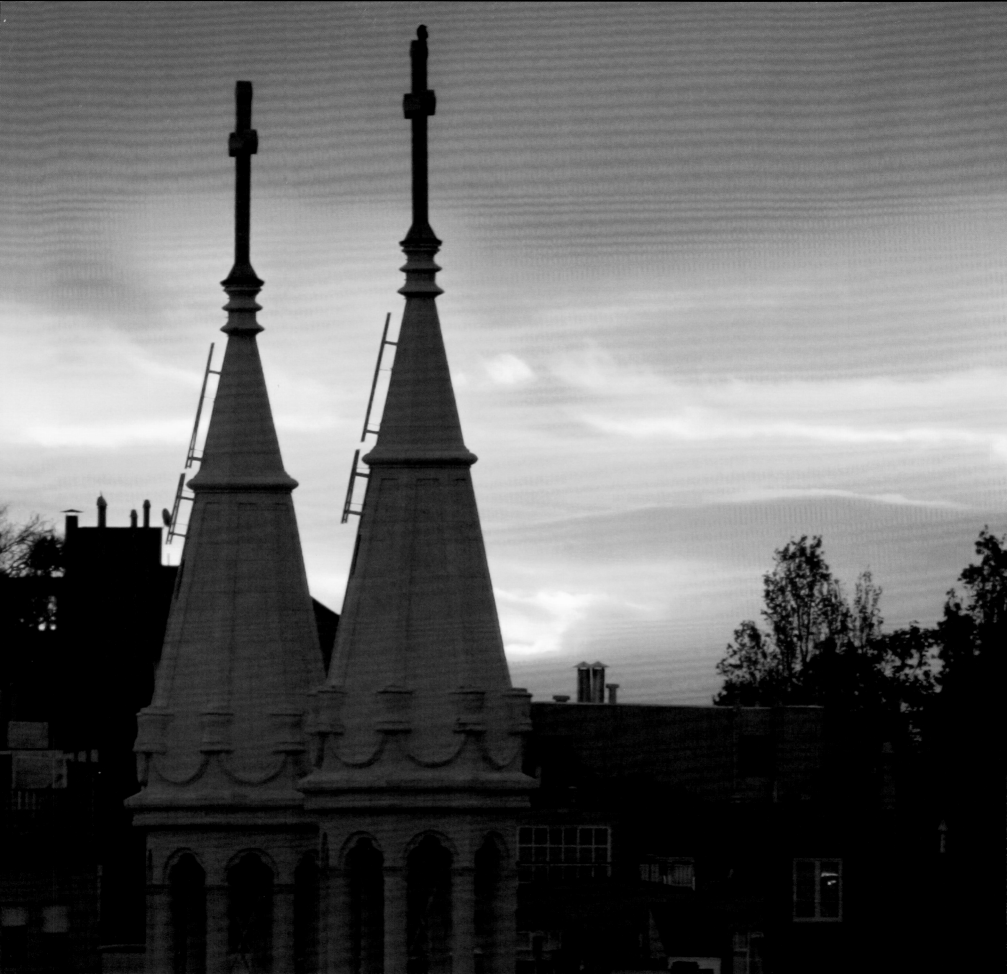

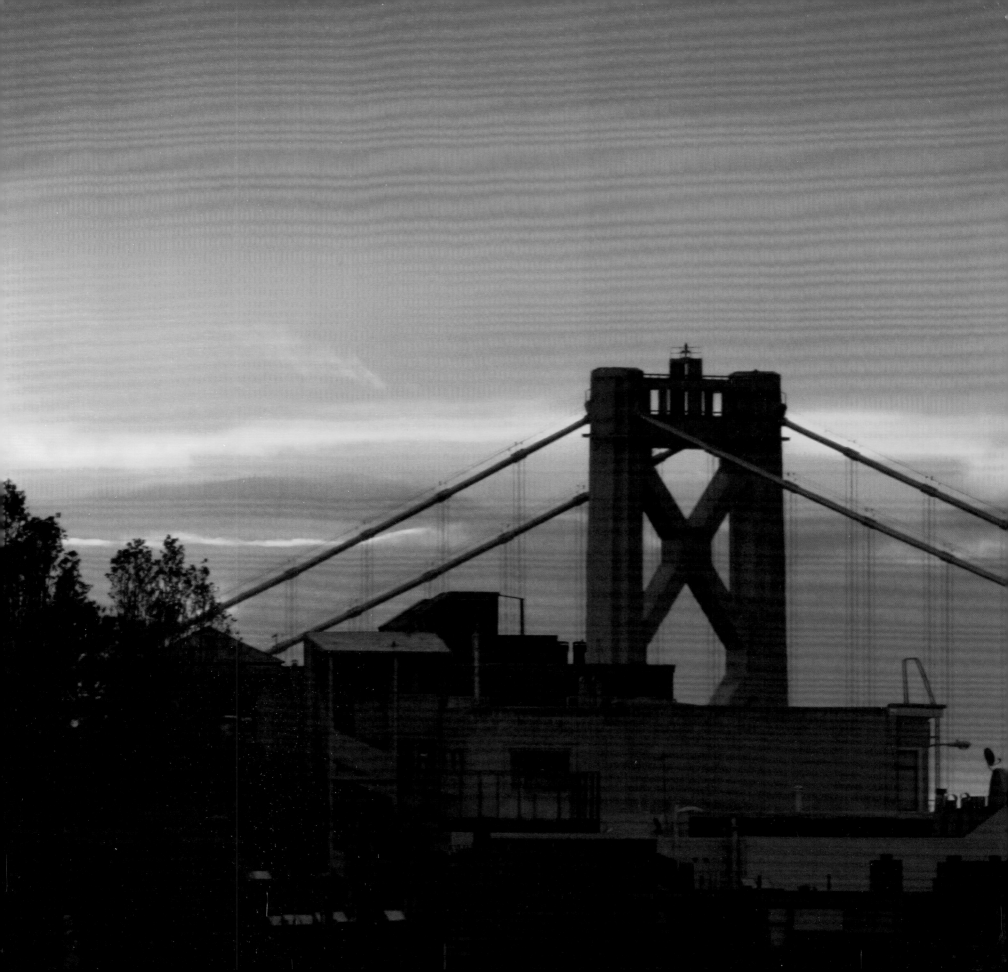

"What I like best about San Francisco is its size. It has nowhere to grow but up."

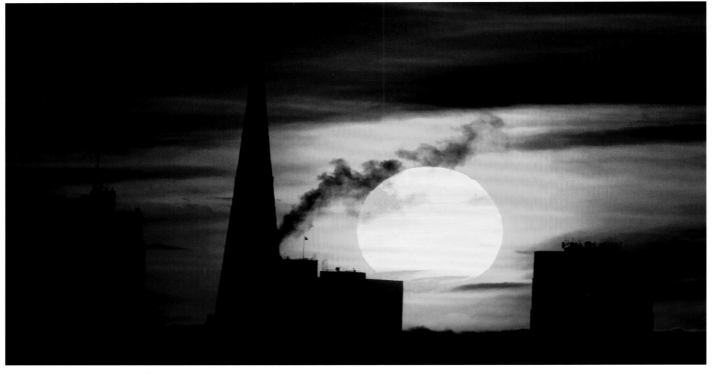

Sunrise, Transamerica Pyramid

"A tight little isle of controlled insanity, where anything and everything happens,
where life is a constant rush of draining emotions,
with gaudy success at the top end of the scale and heartbreak at the bottom."

Seagull, Palace of Fine Arts

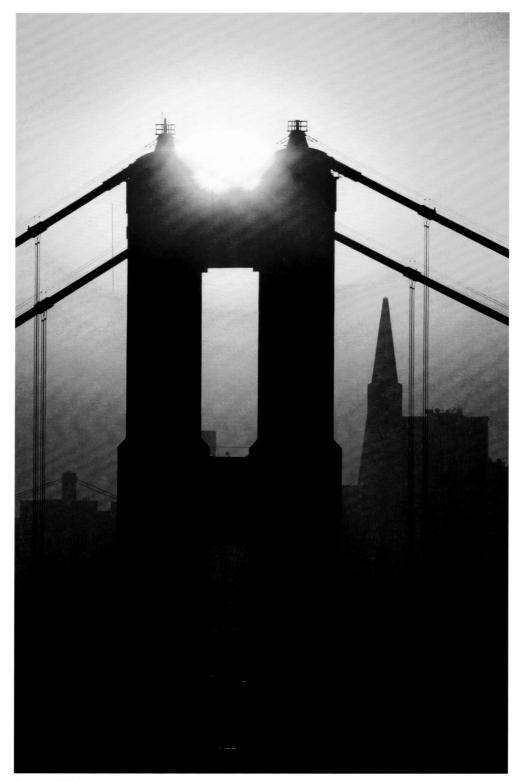

Sunrise, Golden Gate Bridge

"The texture of a city is drawn from its beginnings,
and the tapestry that is San Francisco is strong with legends."

Detail, Golden Gate Bridge

Half moon behind the Golden Gate Bridge cables

"When I was a kid of ten, the place got me right in the old viscera.
I was so dizzy with excitement, I didn't know what had hit me. ...
My gut told me, 'This is it! This is where I want to be.'"

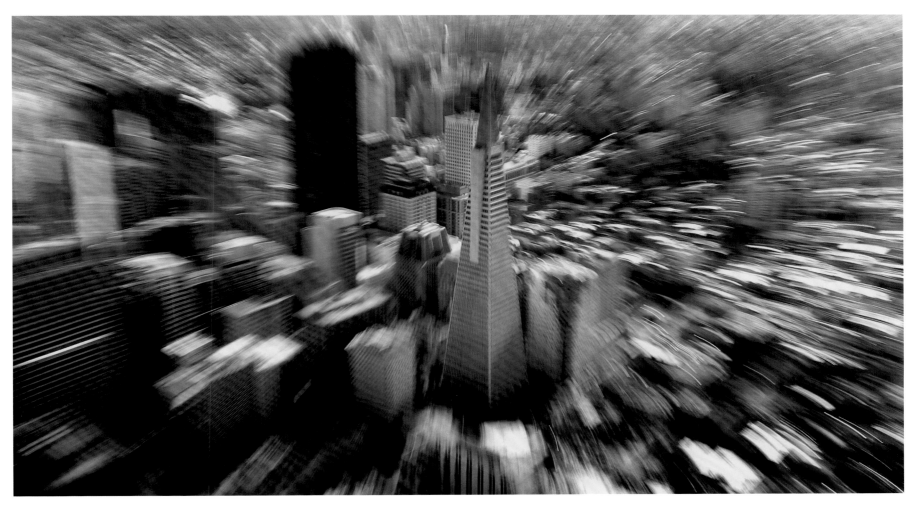

Downtown

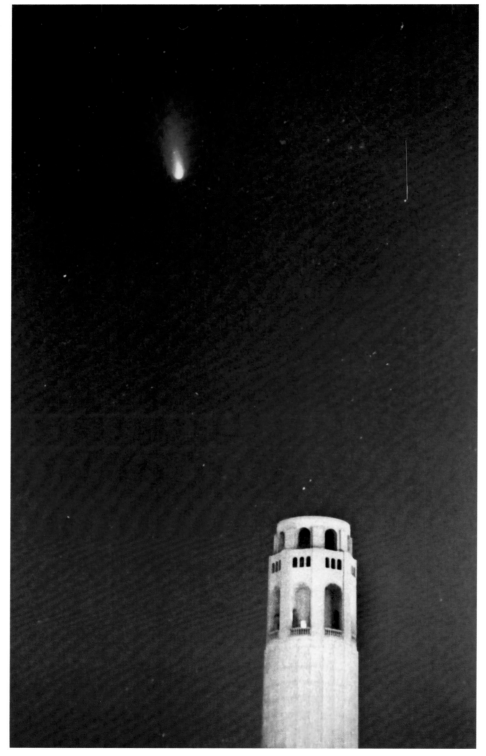

Hale-Bopp Comet, Coit Tower

"San Francisco is all ups and downs, insiders and outcasts,
terrible mistakes and, here and there, a triumph that happened by accident.
Somebody did something right. Nobody knows why."

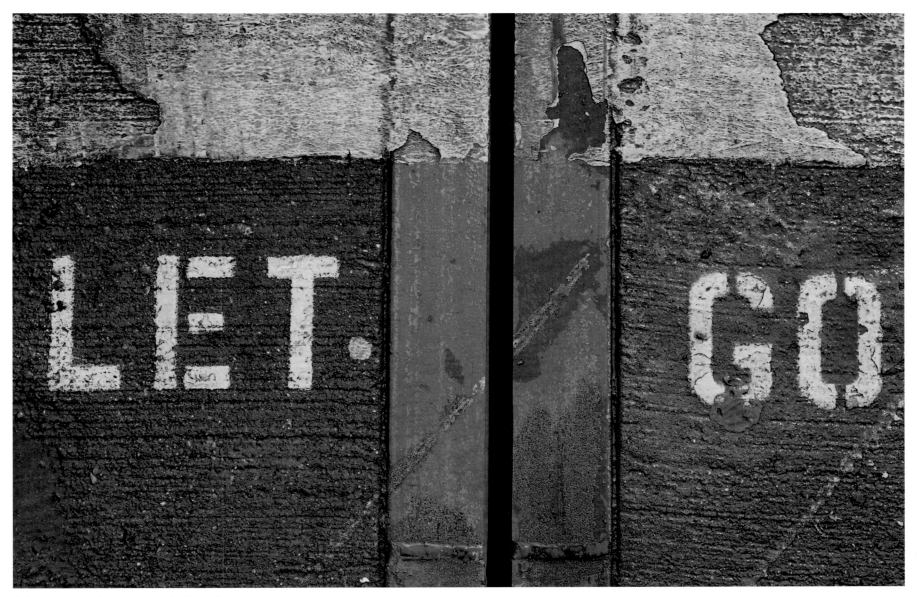

Cable car gripman's instructions, California Street

"There's the sometimes unpardonable pride of the natives, who, even while panhandling on Powell, will say as you dredge up a quarter, 'Beautiful day isn't it?' and gaze around with a blissful smile."

Powell Street cable car

"I think of San Francisco as a merry-go-round, whirling and whistling around this fascinating small piece of land, lighting up every part of the city for a flashing instant."

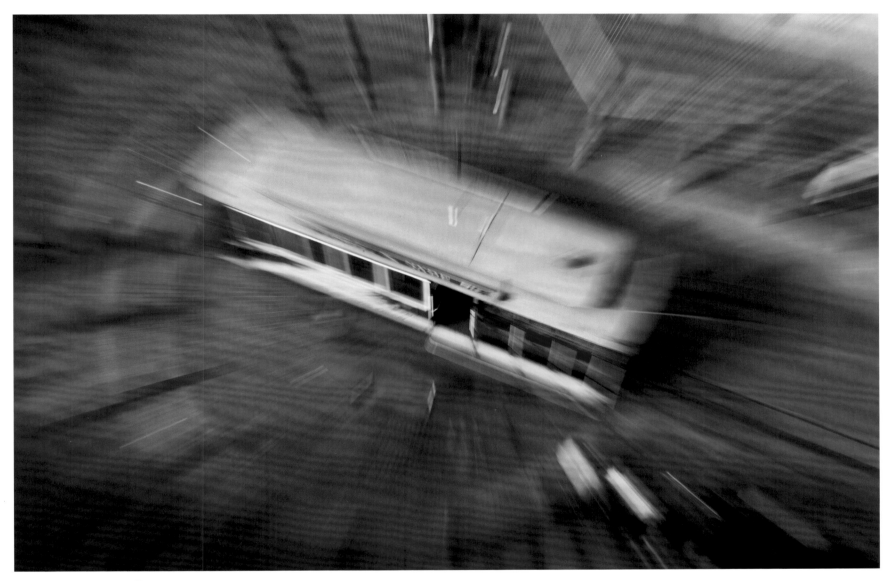

Cable car turntable, Powell Street

"Welcome visitors, to this bay-windowed, fog-swept, sea-girt spit of land. May you be treated well by bartenders and bellmen, boozers and cruisers, cops, cabbies, hippies and chippies. And if you're taken for a ride, I hope you'll agree that the scenery made the trip worthwhile."

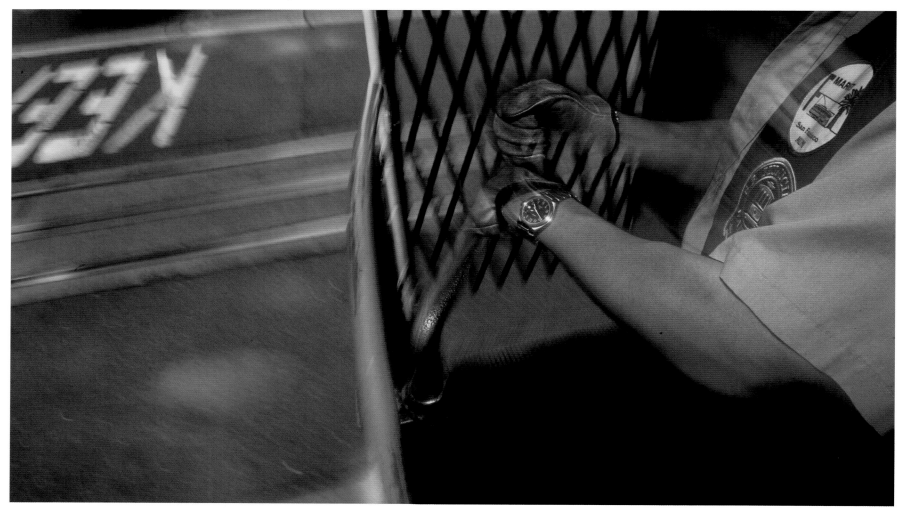

Powell Street cable car

"With all her faults, she's still a beauty."

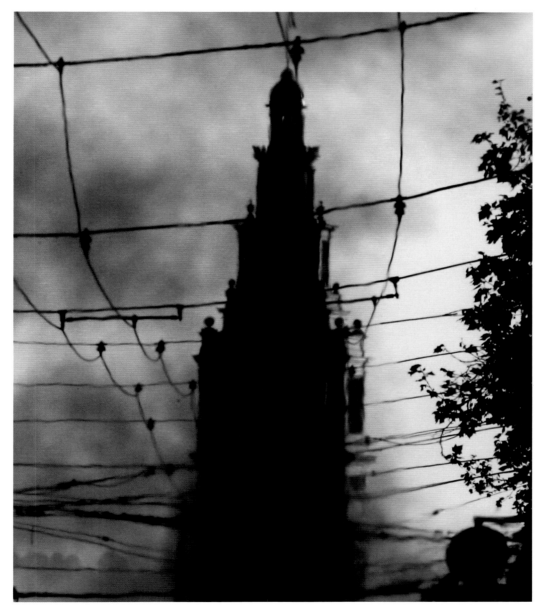

Ferry Building, Market Street

"Being here on an overcast day is like living inside a great gray pearl."

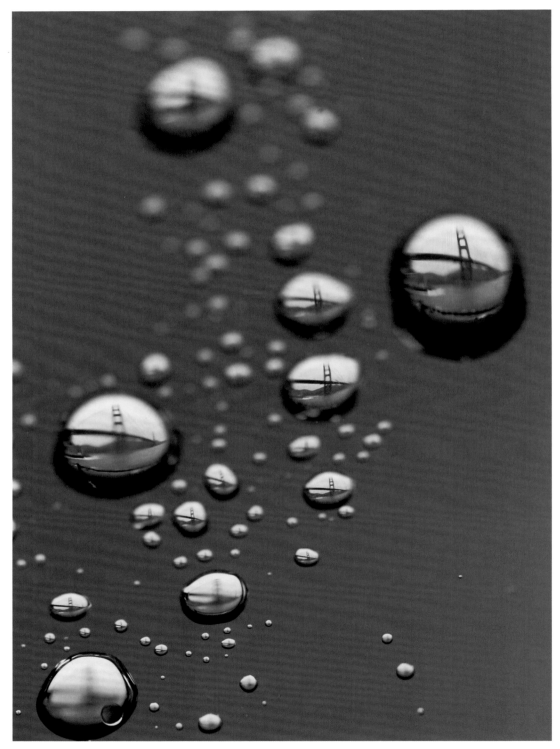

Golden Gate Bridge reflected in raindrops

"A lovely word, bridges. Crossings, connections, the dramatic closing of gaps."

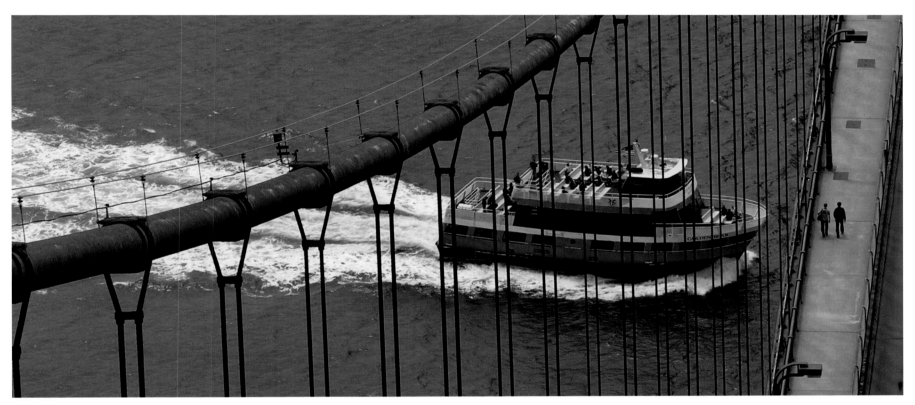

View from the top of Golden Gate Bridge north tower

"The tide was coming in,
slapping at the shore with little waves of affection."

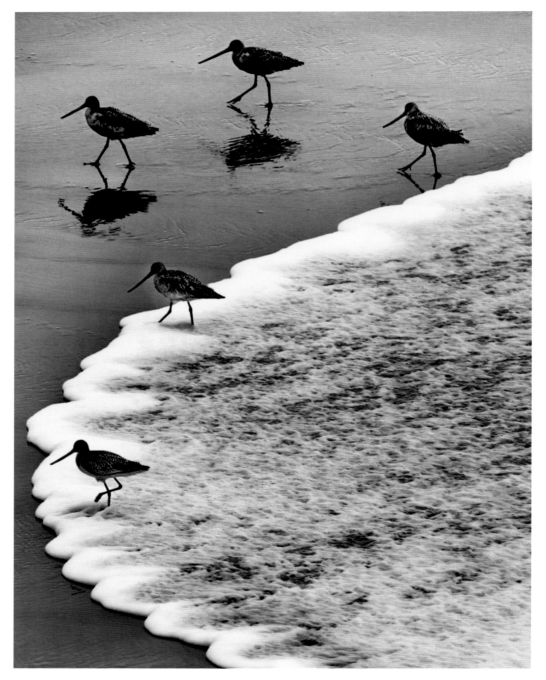

Ocean Beach

"Watching the great ocean make dainty scallops of foam along the beach, realizing you are standing on the edge of a continent, thinking of the men who have stood on this spot before you, back through the years, feeling the same stirrings, sensing the city at your back and adventure somewhere ahead."

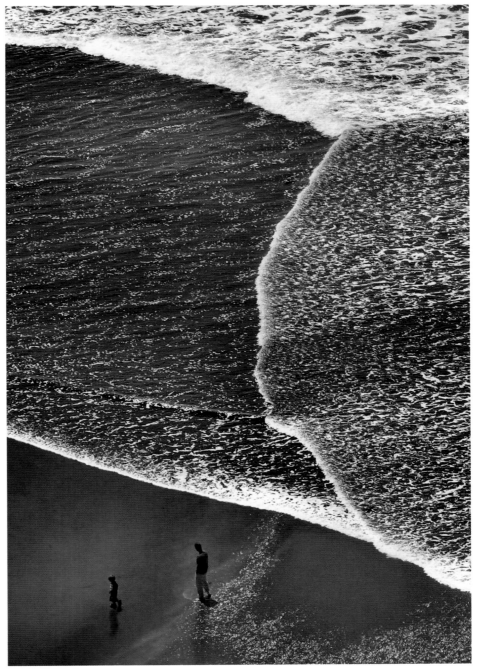

Ocean Beach

Next page: Beach at Crissy Field

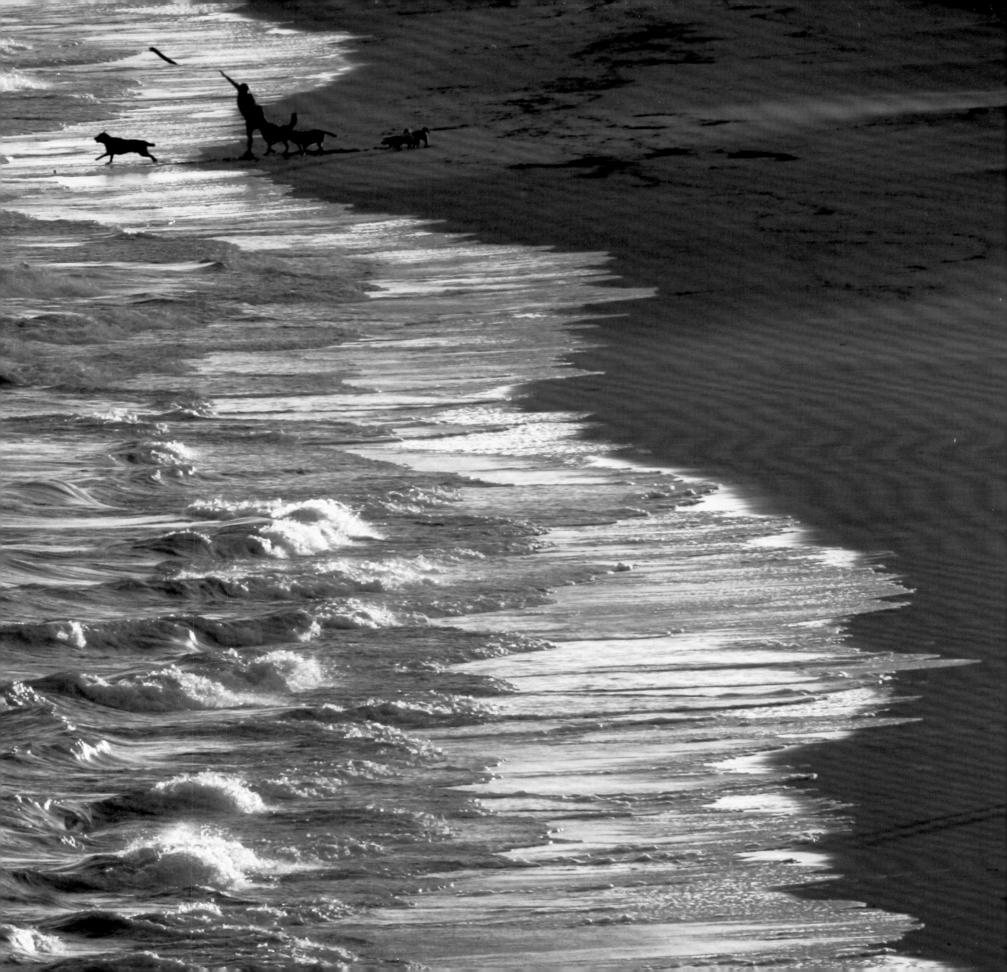

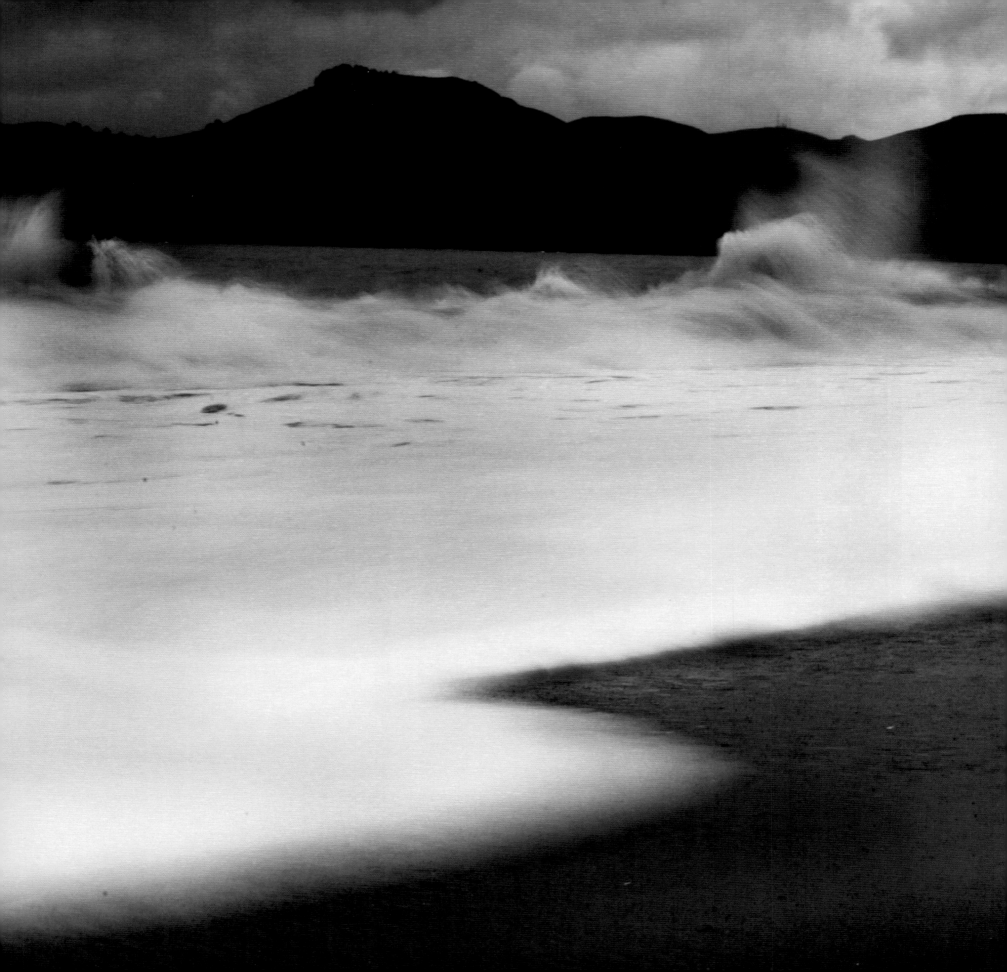

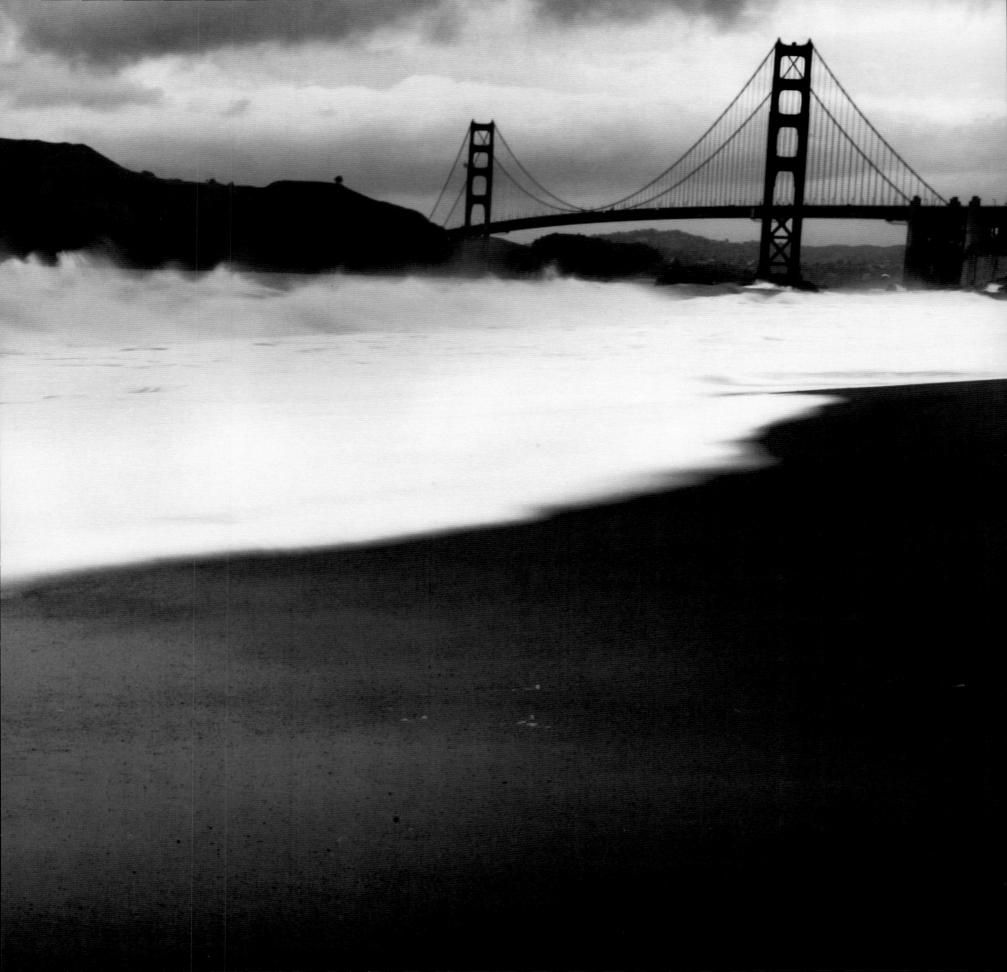

"When the wind is fresh off the sea, and you're walking in the sunshine
with the foghorns already blowing way out there by the Gate, you know this is where you want to be."

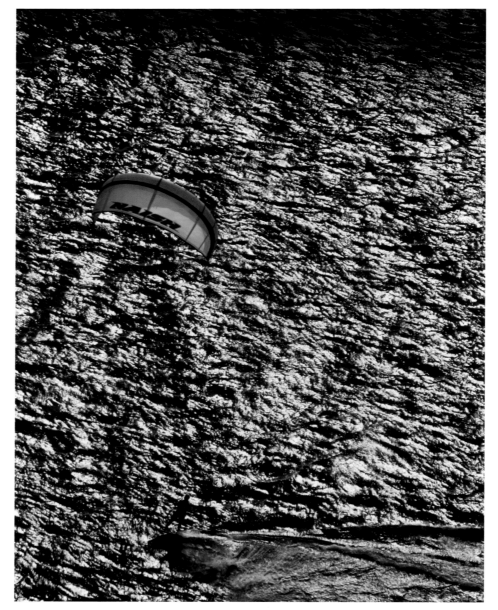

Parasurfing, San Francisco Bay Previous page: Baker Beach

"Cable car city in the rain, chained to the past with wispy memories that always turn out to be, surprisingly, strong as steel, tugging as hard as the cables under the slotted streets. On a gray day they spring back to life, as though waiting for the rain to revive them."

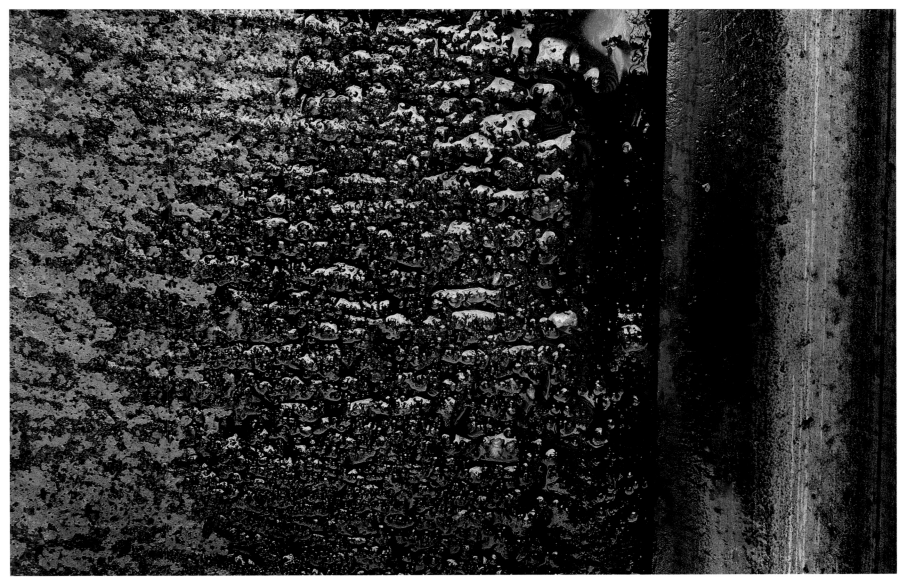

Oil on California Street cable car tracks

"Giddy pritty city with salt in her hair, a bit trying in broad daylight,
much more glamorous at night, with rhinestones and zircons glittering on her empty head,
and here and there a genuine pearl teardrop."

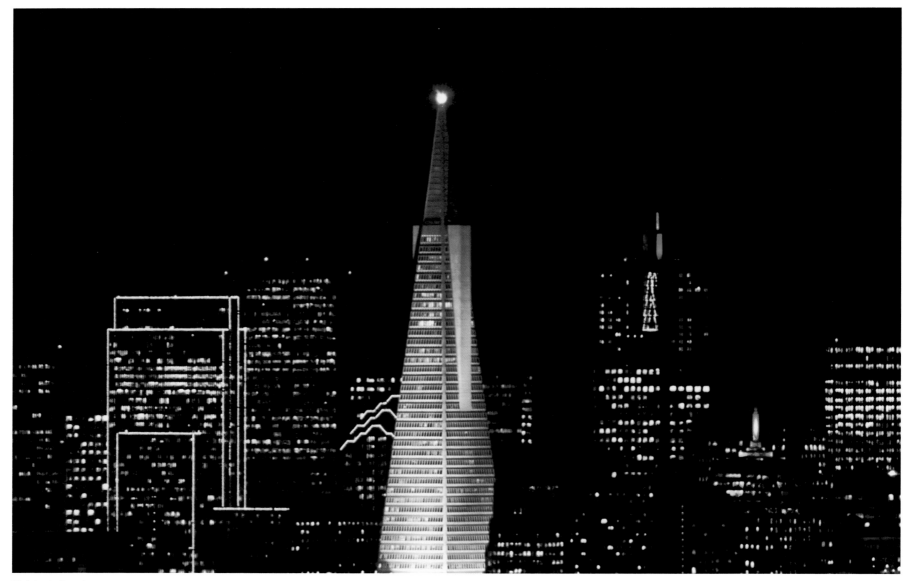

Holiday lights, downtown

"Other buildings may be here to sway, but the pyramid is here to stay.

With its fat bottom, it'll survive any earthquake, and if the city sinks into the sea,

its pointy head will remain visible as our final landmark."

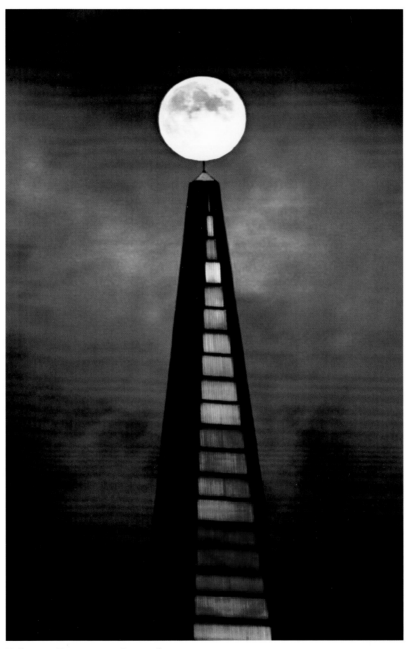

Full moon, Transamerica Pyramid

"San Franciscans have it easier. Even when they go bust they have the view.

True, you can't eat it, but it feeds the soul."

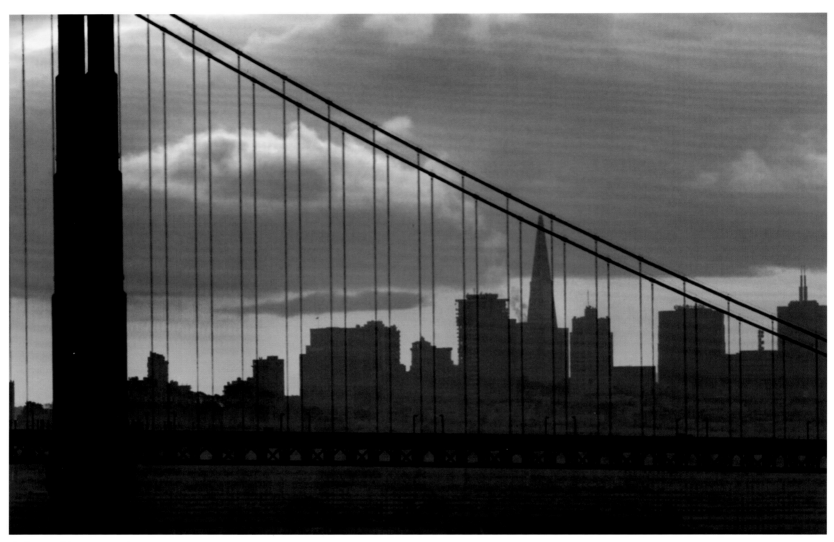

Skyline, Golden Gate Bridge

"Let's take better care of this marvelous creature. They don't make 'em like that anywhere else."

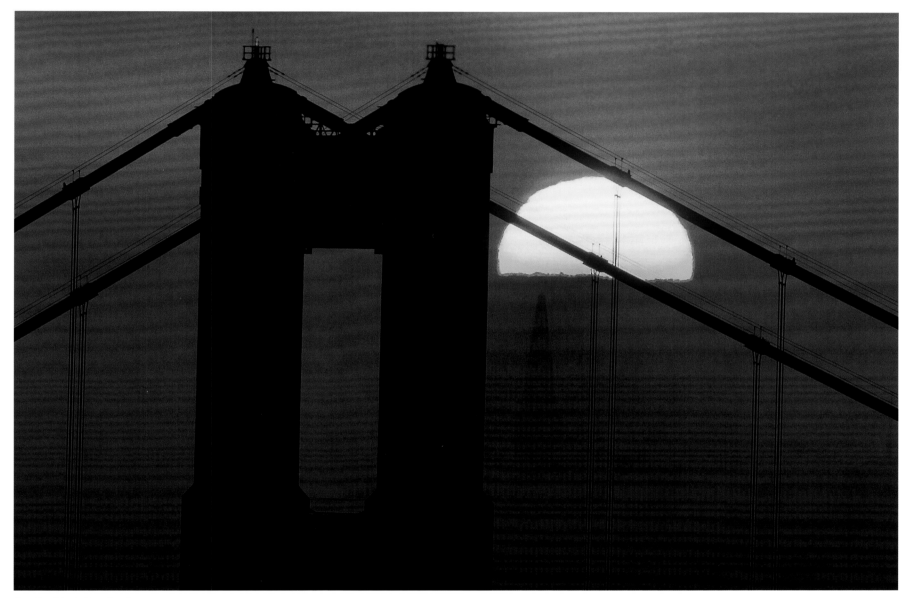

Sunrise, Marin Headlands

"When you're in love with a city, you grope for shadows that vanish at first touch."

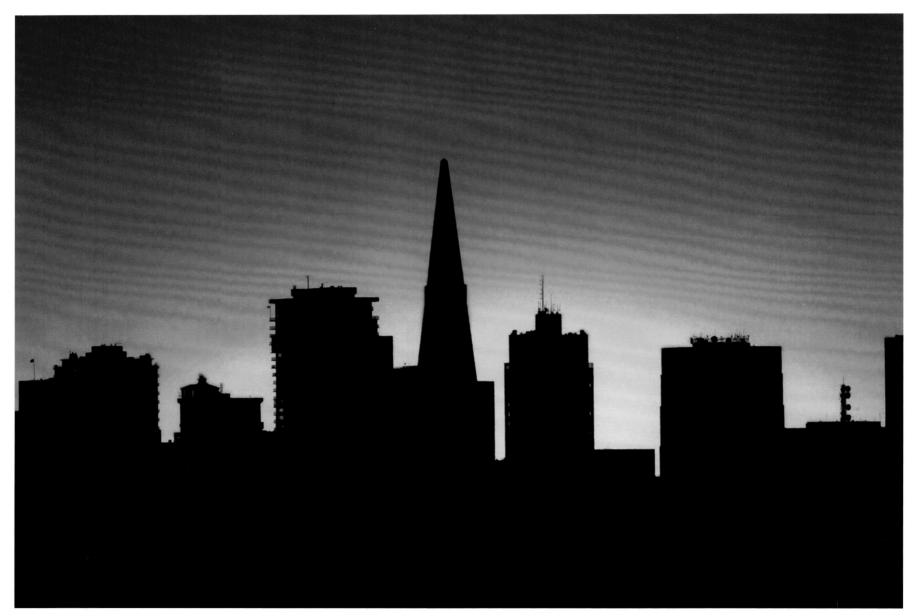

Silhouette

"Telegraph Hill, where Coit Tower is very much an exclamation mark
at the end of an unfinished sentence."

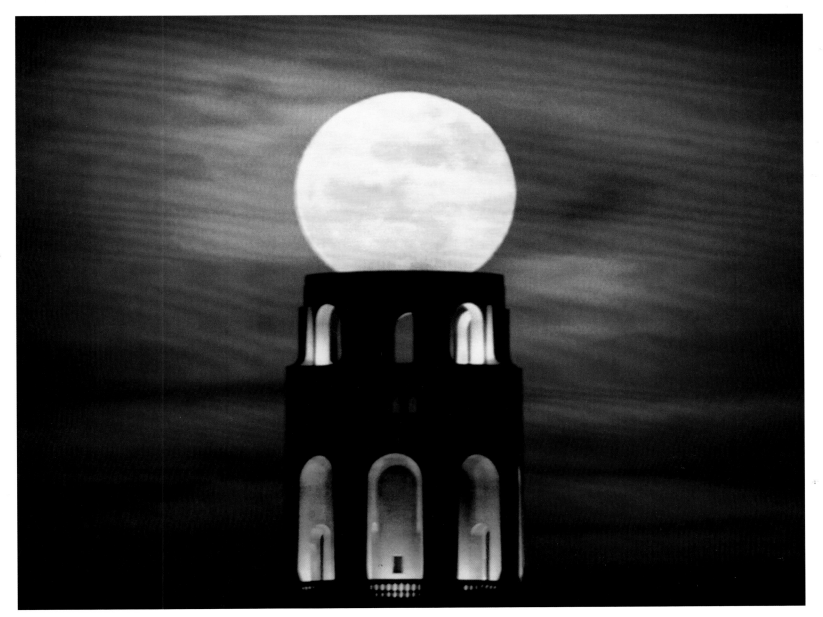

Full moon, Coit Tower

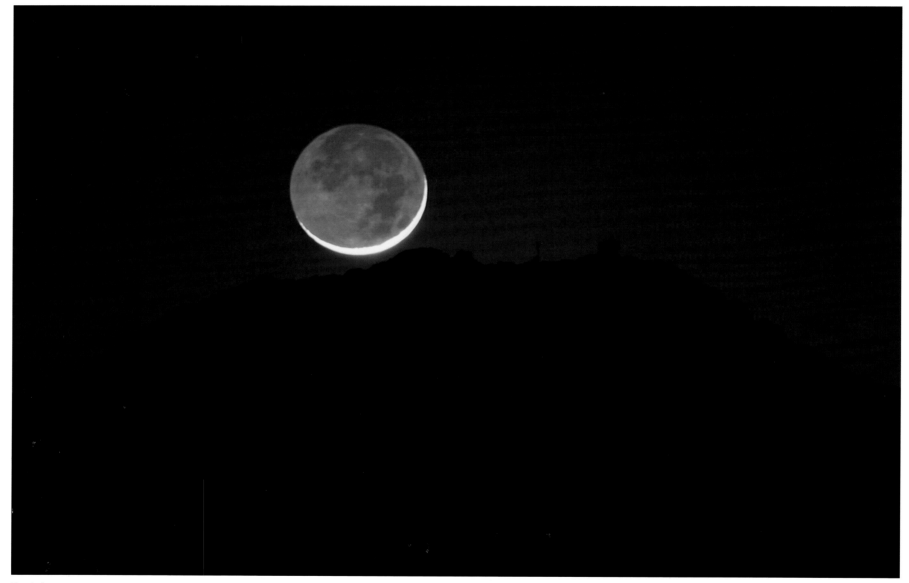

Earthshine moon

"Westernmost city of life and death

and the many imitations thereof, city of sirens and siren songs."

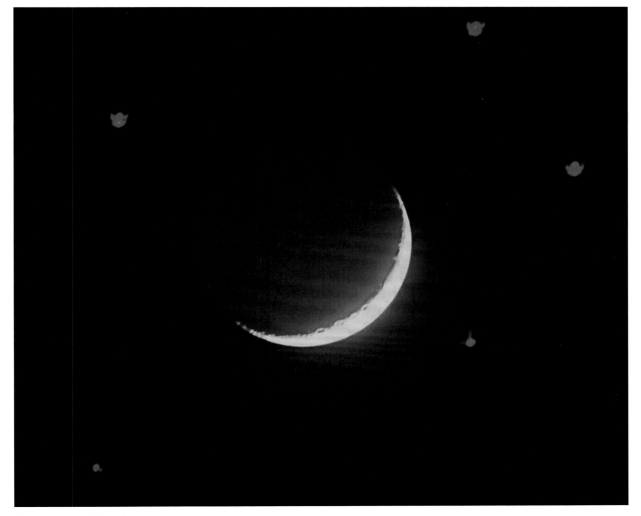

Crescent moon, Sutro Tower

"The fat and careless city, wanting and wasting, spending and elbow-bending, living only for another night under the full autumn moon that climbs steadily higher for a better look at the fun-filled sadness."

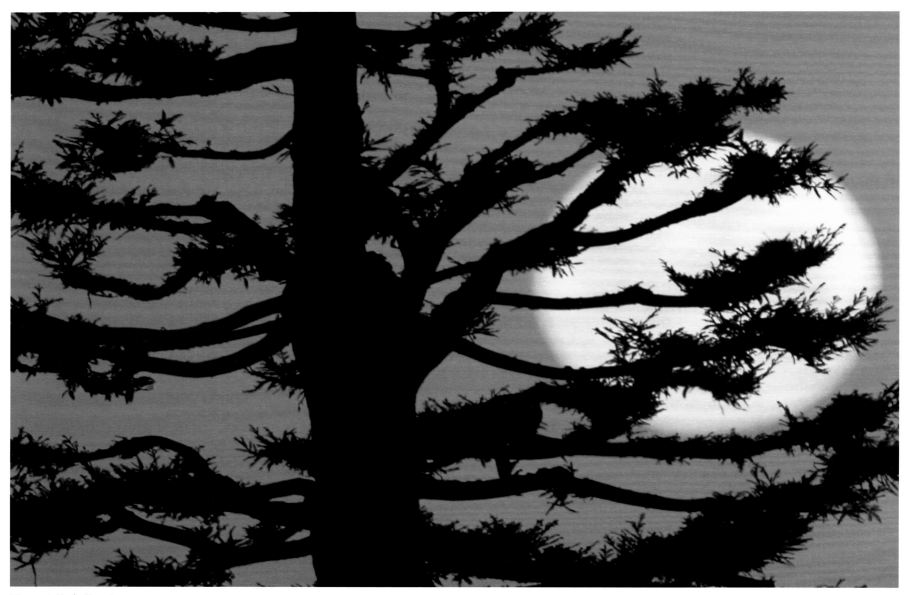

Moonset, Hyde Street

"At gentle dusk ... Even the pyramid takes on a glamorous thrust. In the daytime,
it resembles a gawky, big-eared kid who's about to say, 'Aw shucks.'
Awash with lights, its ego becomes more assertive."

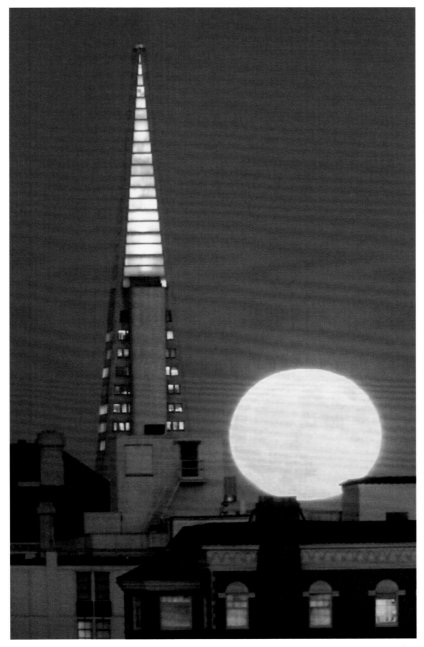

Moonrise, Pacific Heights

Next page: Bay Bridge

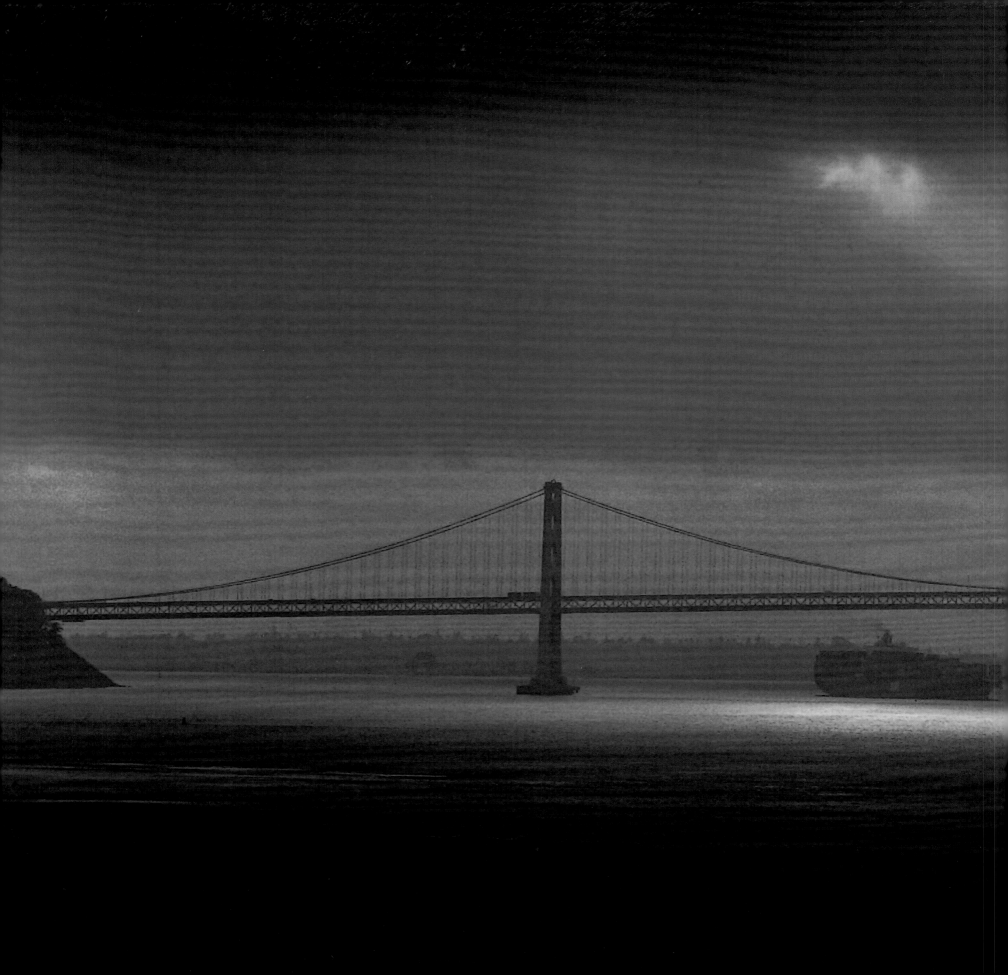

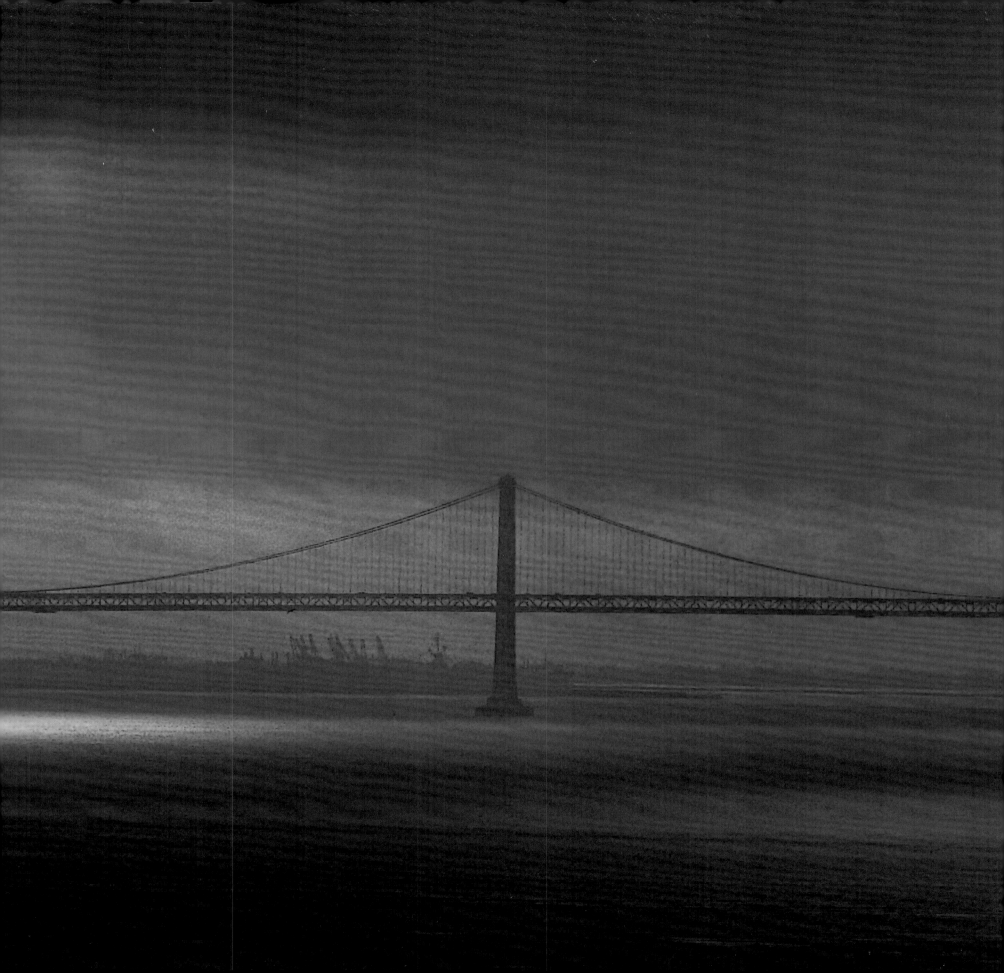

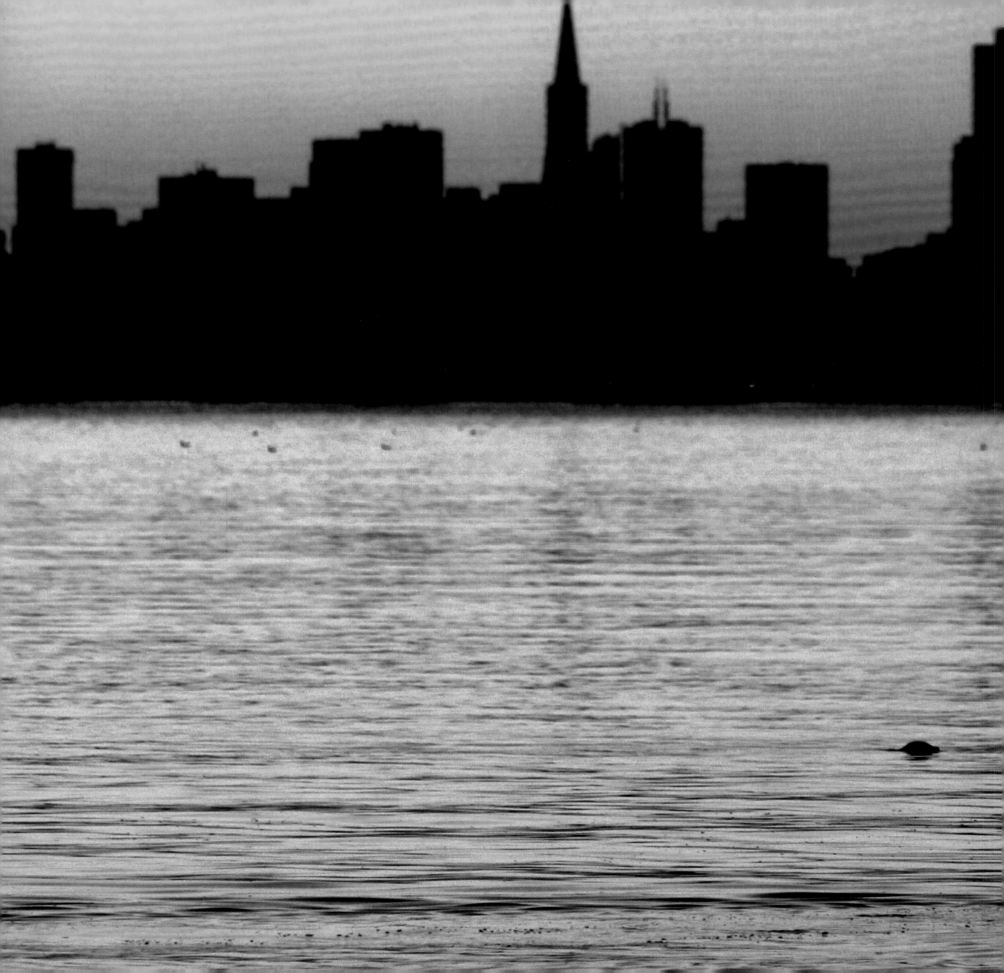

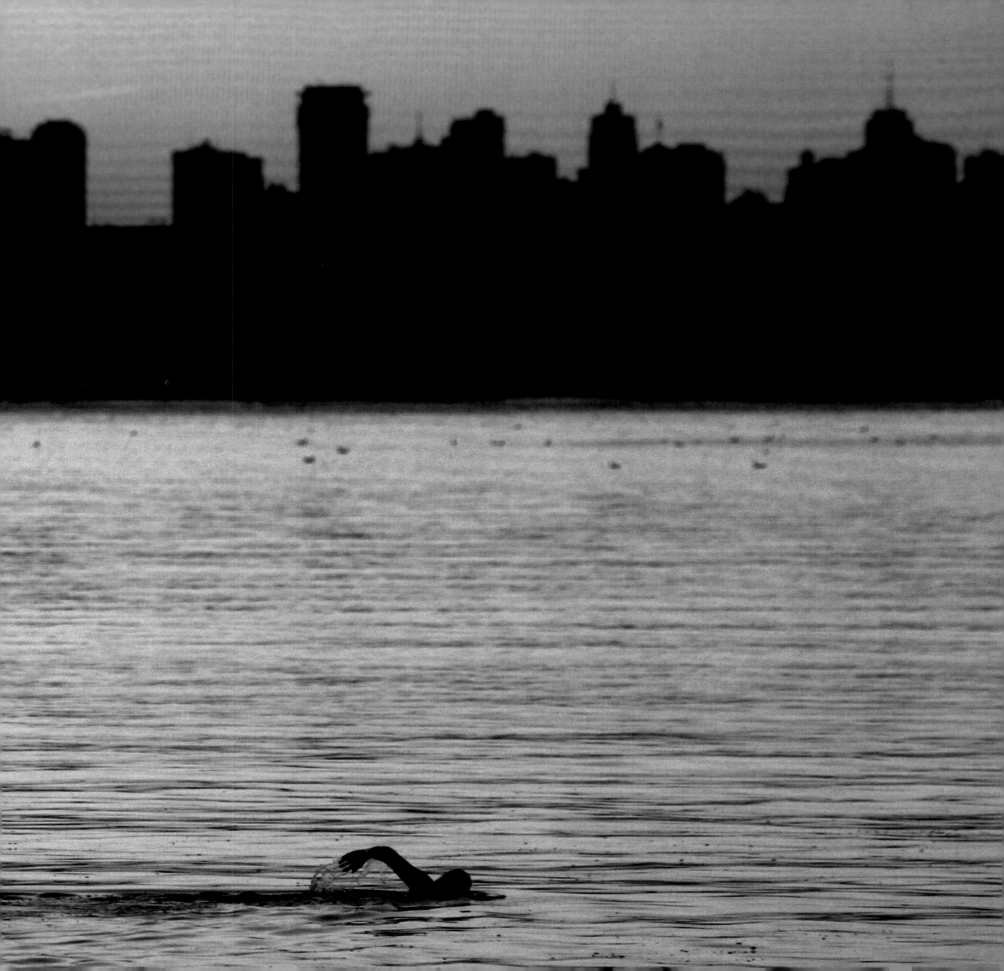

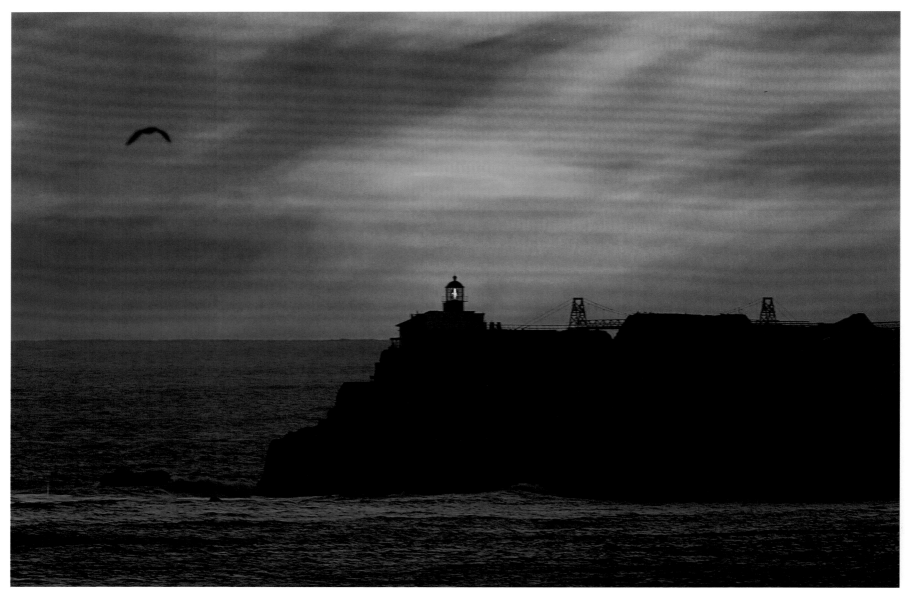

Sunset, Point Bonita

Previous page: Morning swim, San Francisco Bay

"The old town is still around somewhere,
hidden behind and between the newer buildings that scrape the sky
and unravel the fabric of a neighborhood."

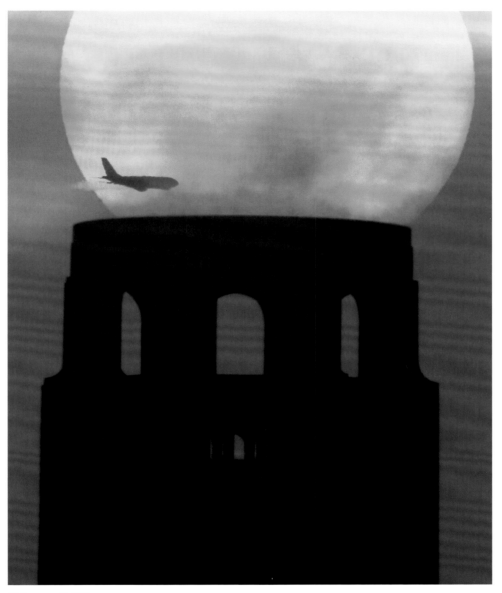

Rising sun, Coit Tower

"There is no stupidity great enough to ruin the majesty of the Golden Gate Bridge.

It has been the subject of terrible poetry and worse paintings, but it rises easily and grandly above the mundane,

its towers poking through the fogs, natural and man-made."

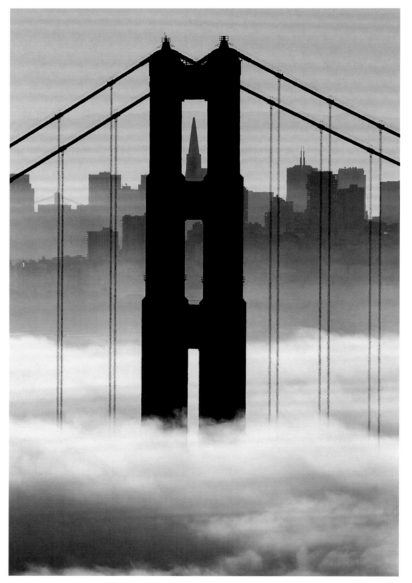

Fog, Golden Gate Bridge

"A wall of thick, dirty fog rising genii-like from the Pacific,

while a finger of whiter, puffier stuff feels its way into the bay,

twisting this way and that till it conforms to every contour, snugly and coldly."

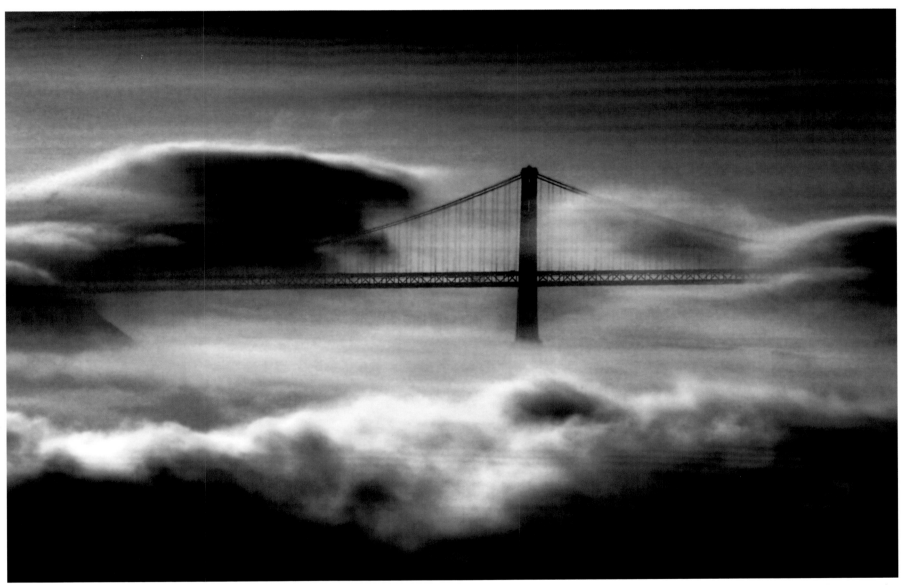

Fog, Bay Bridge

Next page: Fog, Golden Gate Bridge

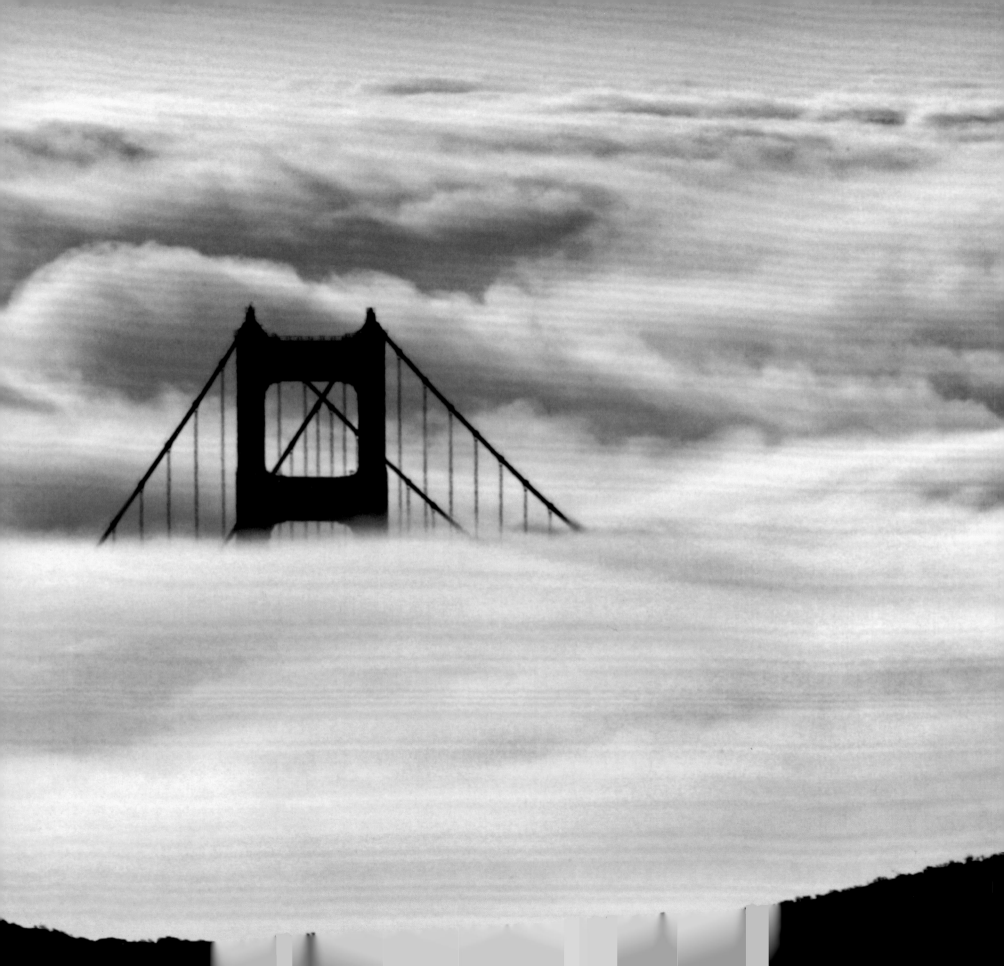

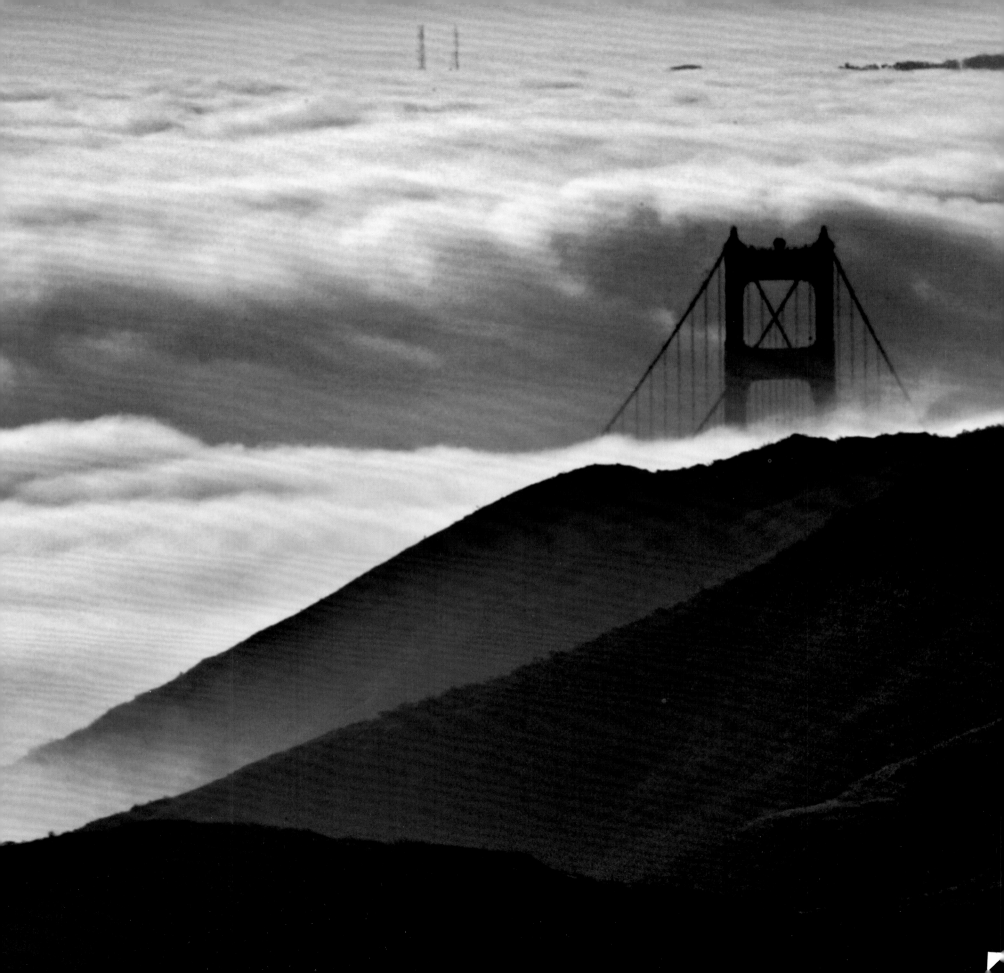

"It's a town that is forever grabbing you by the throat and saying,

'Look around, see what's going on, feel it, experience it.

You don't have to enjoy it. Just don't turn your back on it, OK?'"

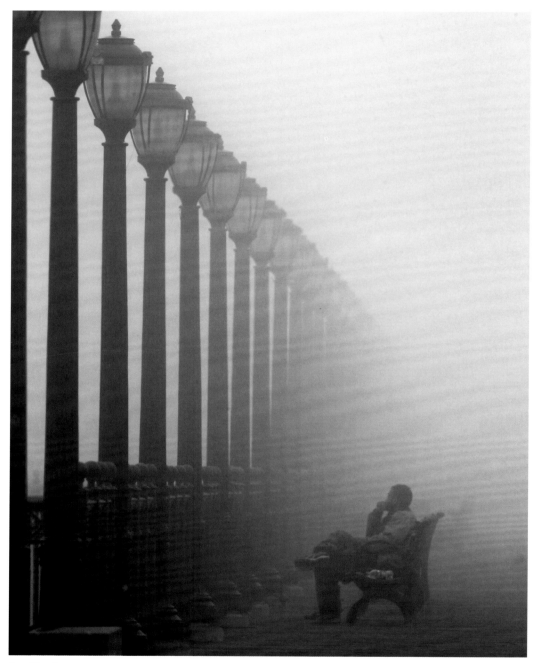

Fog, Pier Seven

"A city that is essentially gray, gray as the fog,

the Rock, the bay and the hair of those who love it best."

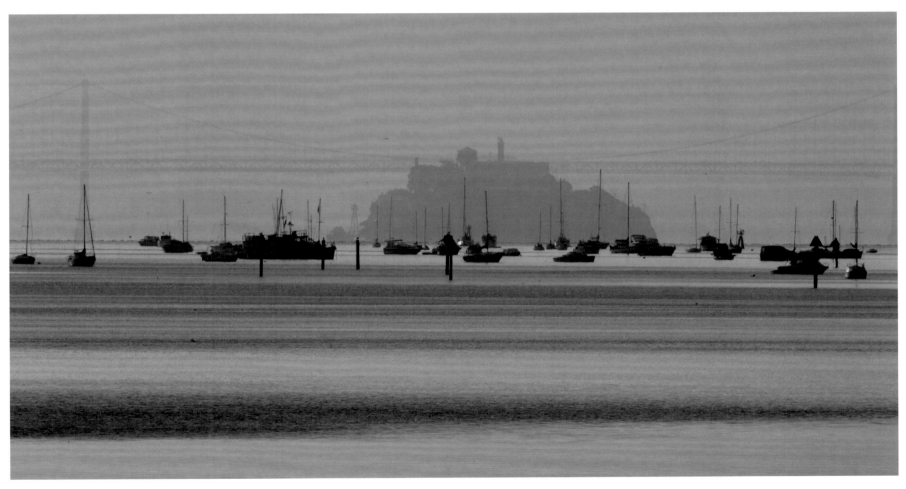

Alcatraz

"It is raining, and suddenly the city looks old, showing every one of the 1,001 nights it has frittered away every year for a hundred-odd years of climbing hills, putting on frills and ducking down back alleys for a quick one — preferably after hours."

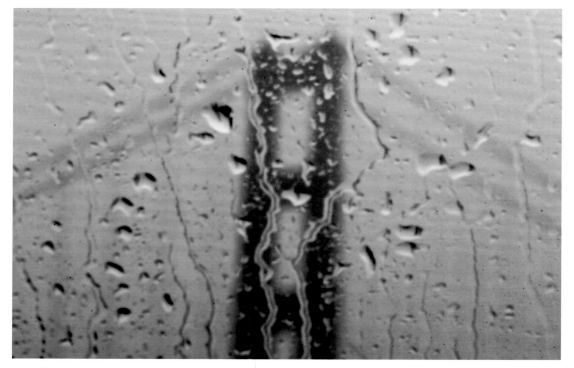

Through rain on windshield, Golden Gate Bridge

"San Francisco is definitely a show, with magnificent sets, a colorful cast of thousands, several good songs and, one hopes, a happy ending."

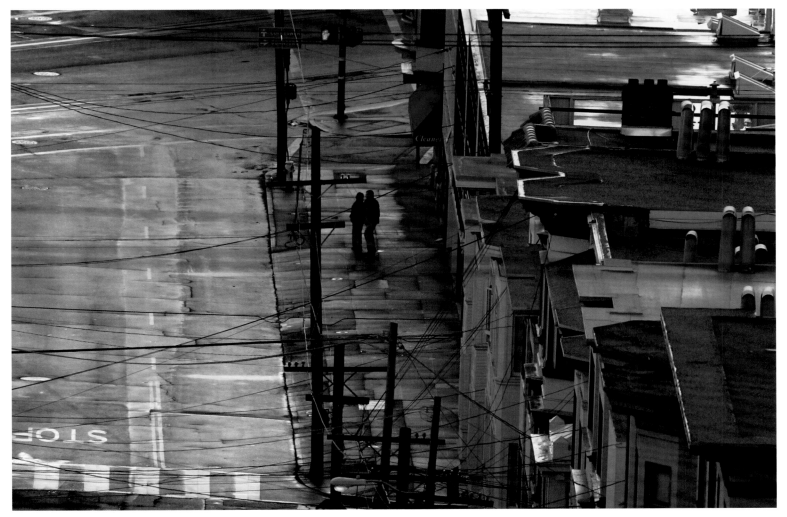

North Beach

"We may have trouble parking, but when we do find a space,
we have someplace to go."

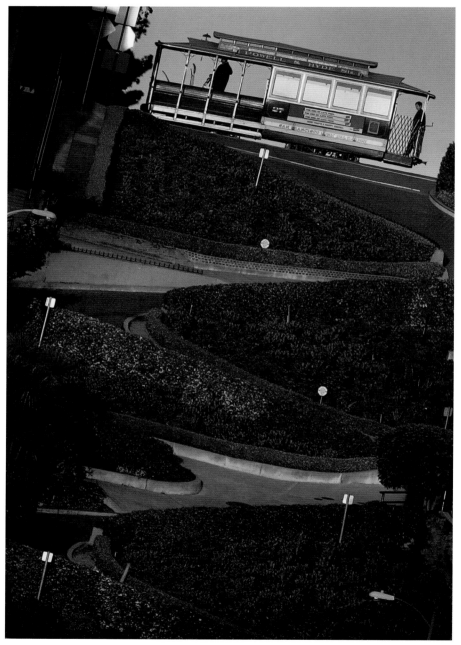

Lombard Street

"Tourists enriched us by $61 million last year [1966] —
and for that amount, LET'em say Frisco."

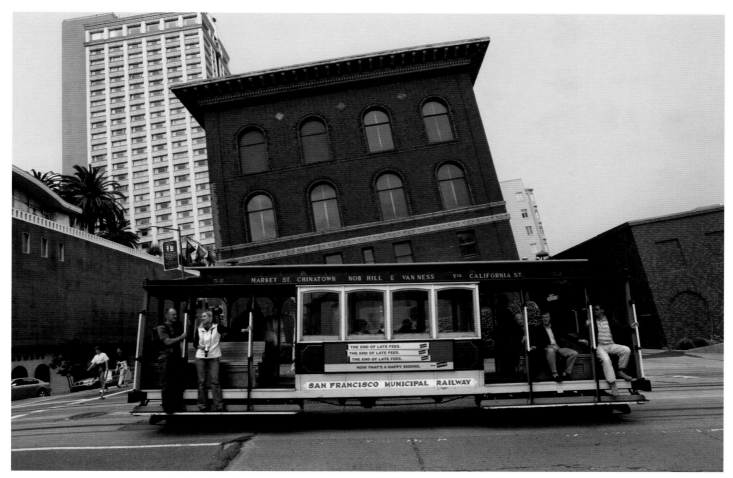

Cable car, California Street

"A magic carpet afloat on a misty sea, a faraway near-at-hand secret garden of unearthly delights, a place of mysterious lights high in dark buildings or floating in the invisible bay that once knew oyster pirates and shanghai'd sailors crying for help."

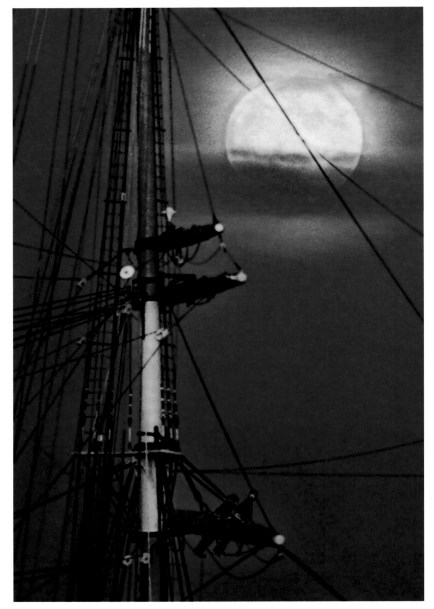

Sailing ship *Balclutha*, Hyde Street Pier

"I keep telling you, it's a great town. You've got to be crazy to think so and crazier not to."

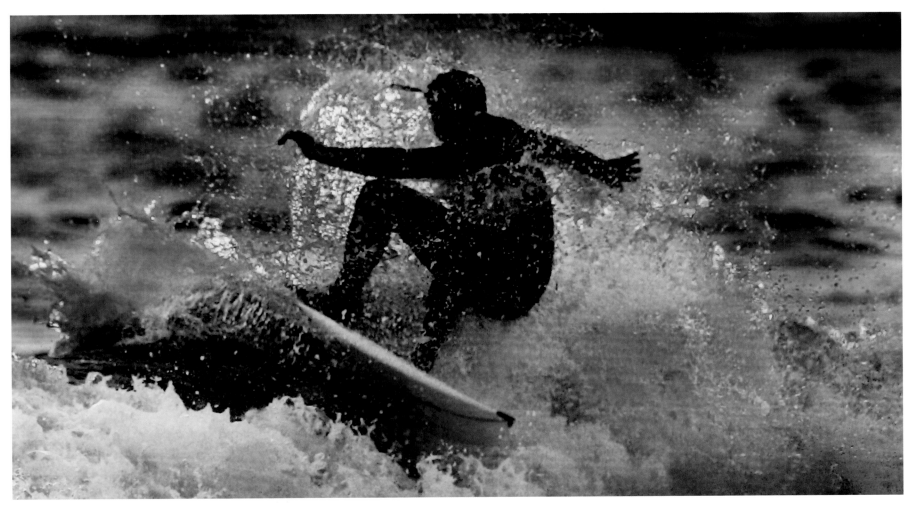

Sunset surfing , near Marin Headlands

"Maybe there is no explaining San Francisco, just as there is no accounting for tastes. Let's put it down as a happy accident, this conglomeration of reasonably sympathetic souls thrown together at one of the pleasanter ends of the earth."

Pier near Fort Point

"Strolling past the bobbing masts at St. Francis Yacht Club ... black tide foaming against the breakwater with a curled white lip, a gull screaming overhead ... I got that old feeling again, that special love for a special place."

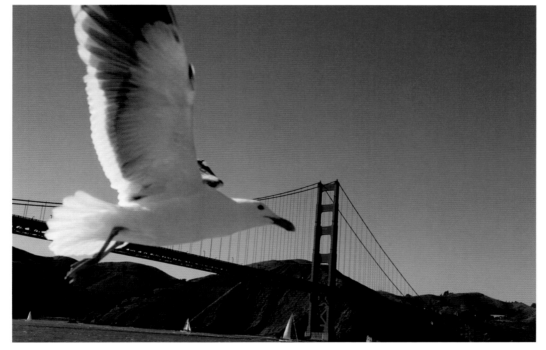

Seagull, Golden Gate Bridge

"Some people become San Franciscans almost immediately, feeling the poetry, sensing the specialness, seeing what makes the city great and not so great, boning up on the history and walking the streets with glamorous ghosts at their elbows. Others can live here all their lives and never get the message."

Sunrise, California Street

"The San Franciscan is forever a tourist in his own home town,

mingling with the tourists from elsewhere."

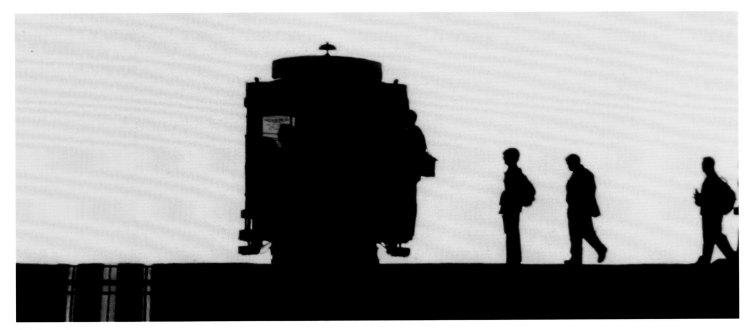

California Street

"A city where you can get a sunburn in the fog and pneumonia in the sun,
freeze during baseball season and swelter during football,
and read any morning that 'it was the coldest day since last August.'"

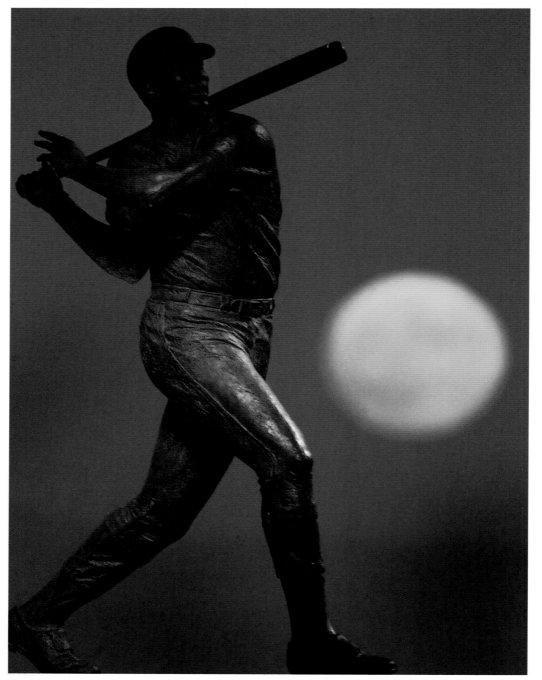

Moonrise, Willie McCovey Cove

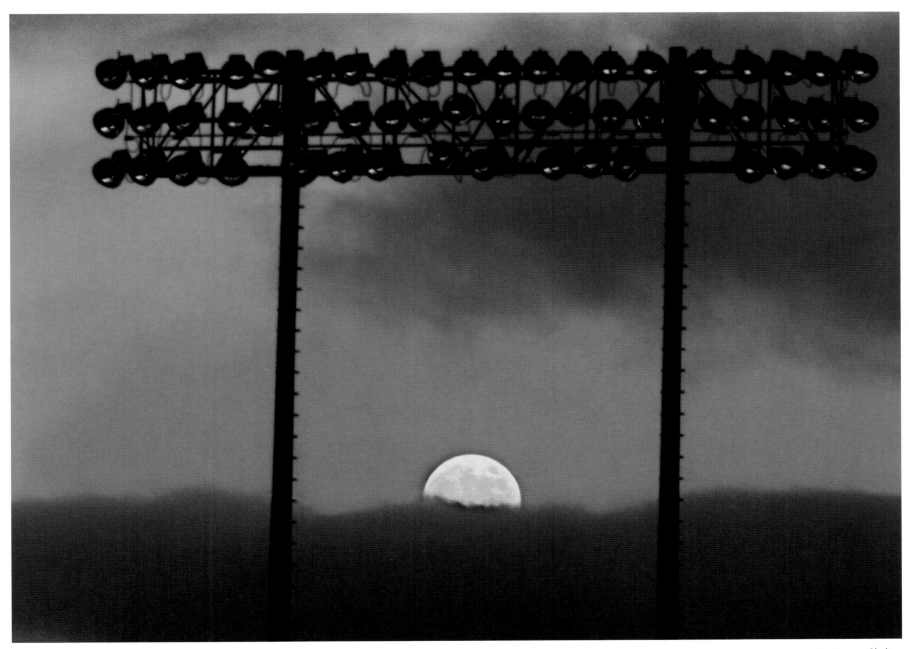

Full moon, Candlestick Park

Next page: Skyline

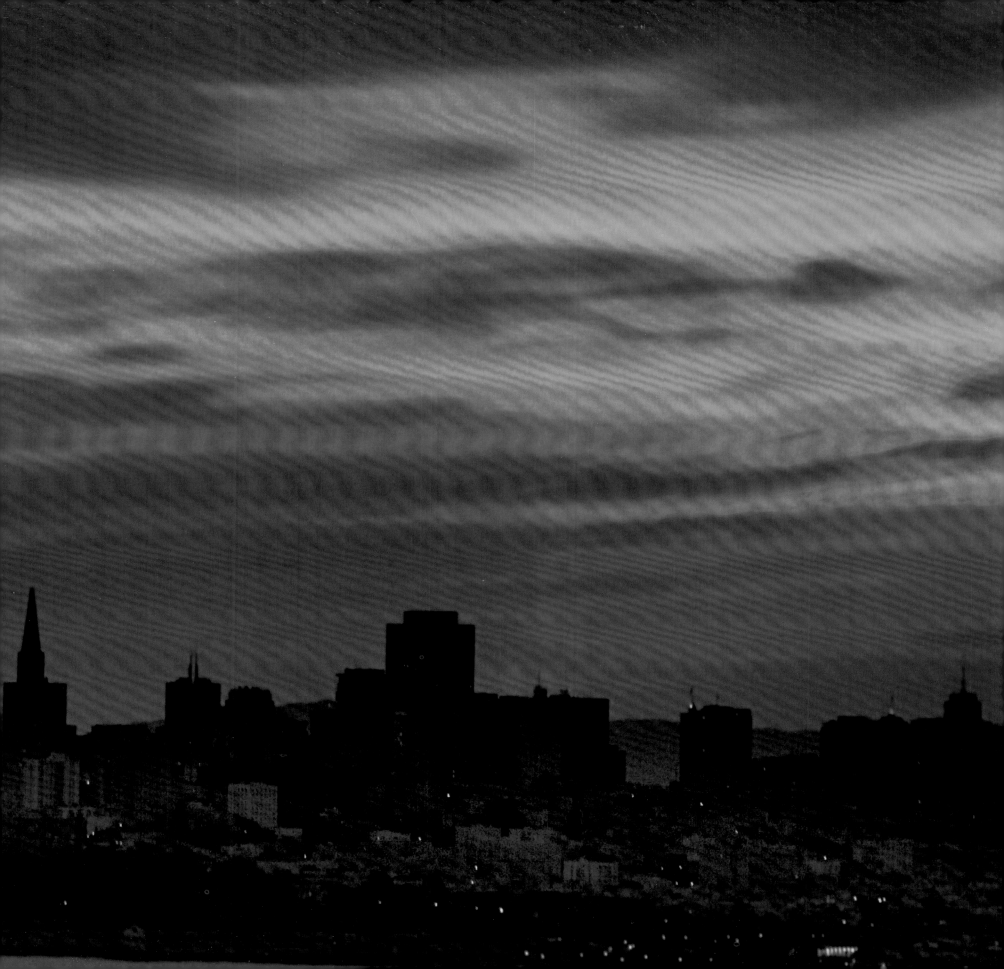

"A beguiling, bewitching, bewildering city, this."

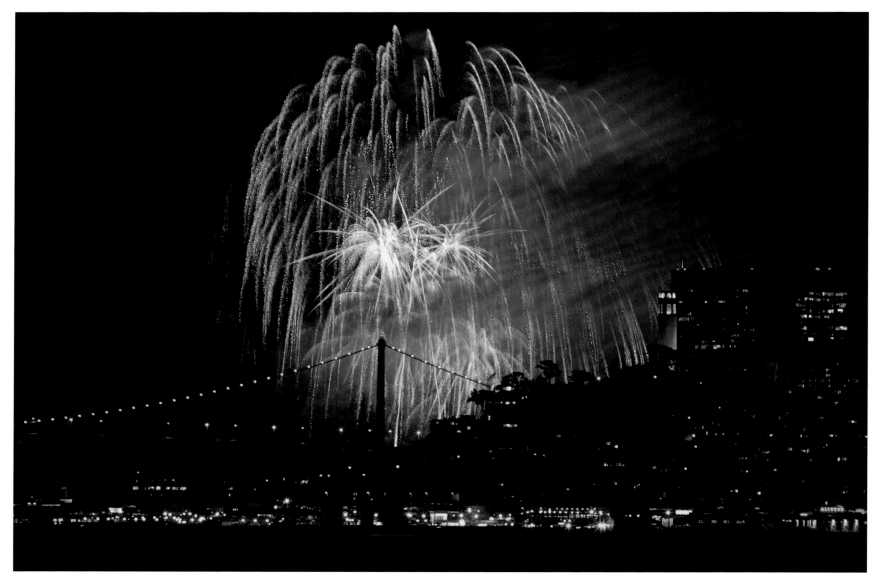

Fireworks, skyline

"You can cross the Golden Gate a thousand times and feel the same thrill each time —

the thrill of being involved with a masterpiece."

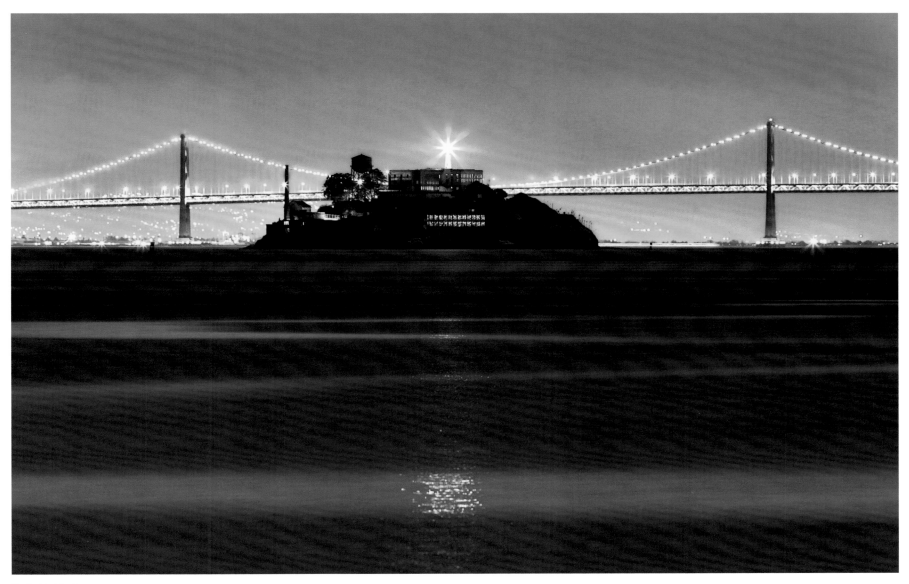

Twilight, Alcatraz

"San Francisco, a small, well-crafted item, rare, expensive, sparkling, depressing.

A city you can wear on your charm bracelet or around your neck.

A pet of a city that will turn on you without warning. Housebroken but not tamed."

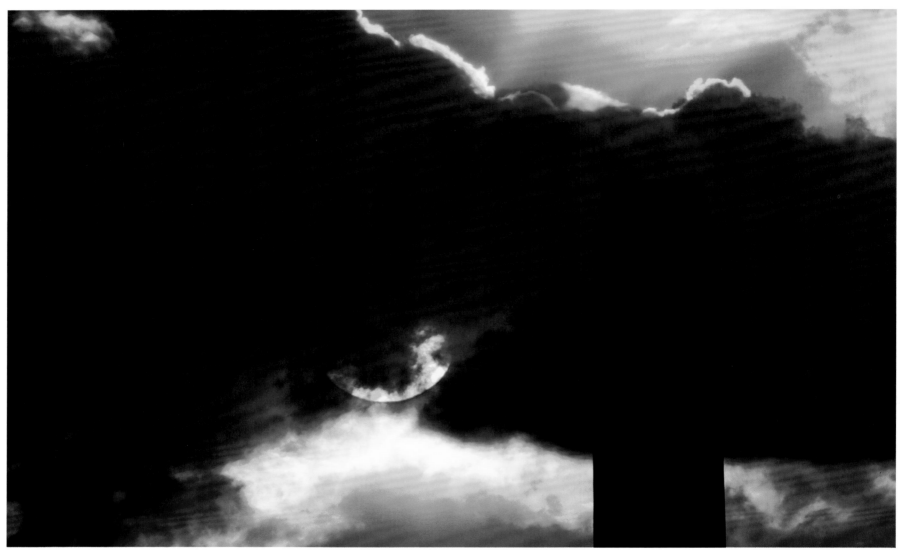

Clouds, Hyde Street

"For all its contradictions . . . San Francisco remains a beacon, always with that dangerous streak of insanity, built in at birth."

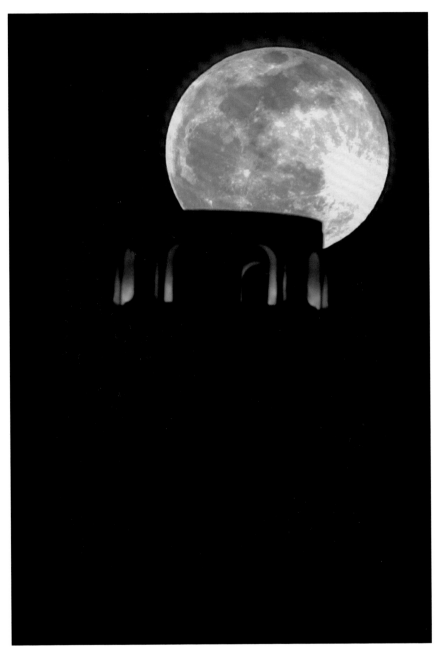

Full moon, Coit Tower

"There's just no doubt about it. Sanfransensual it is."

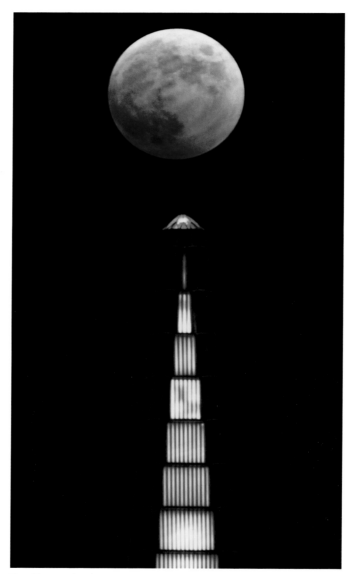

Total lunar eclipse, Transamerica Pyramid

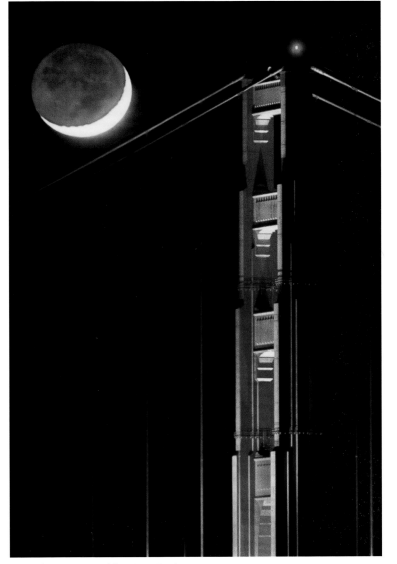

Earthshine moon, Golden Gate Bridge

"It's the indescribable conglomeration of beauty and ugliness that makes San Francisco

a poem without meter, a symphony without harmony, a painting without reason — a city without an equal."

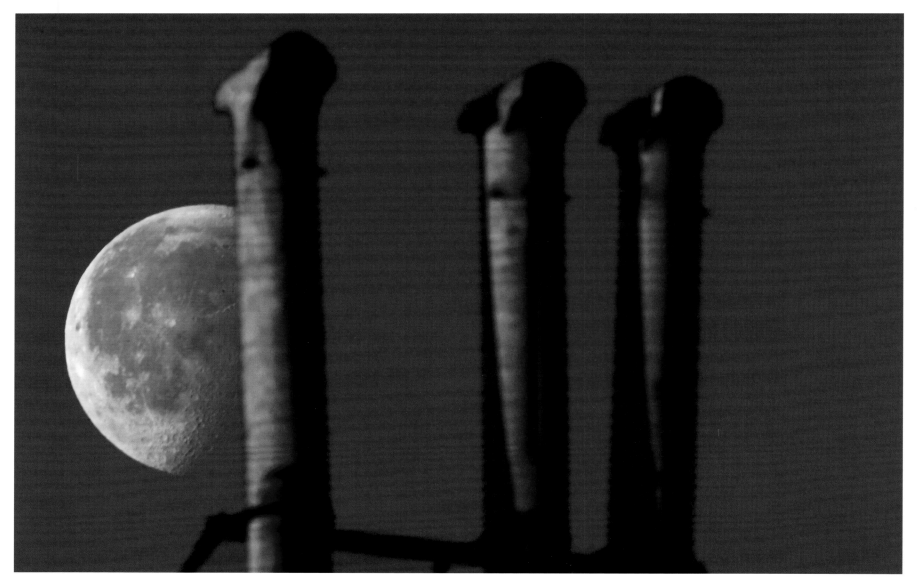

Moon meets earth objects, Hyde Street

"Once you've caught the feel of the city by the bay, once you've known the people, once you've explored the citadels and the basements and the alleys and the penthouses, you know that news is breaking around the clock."

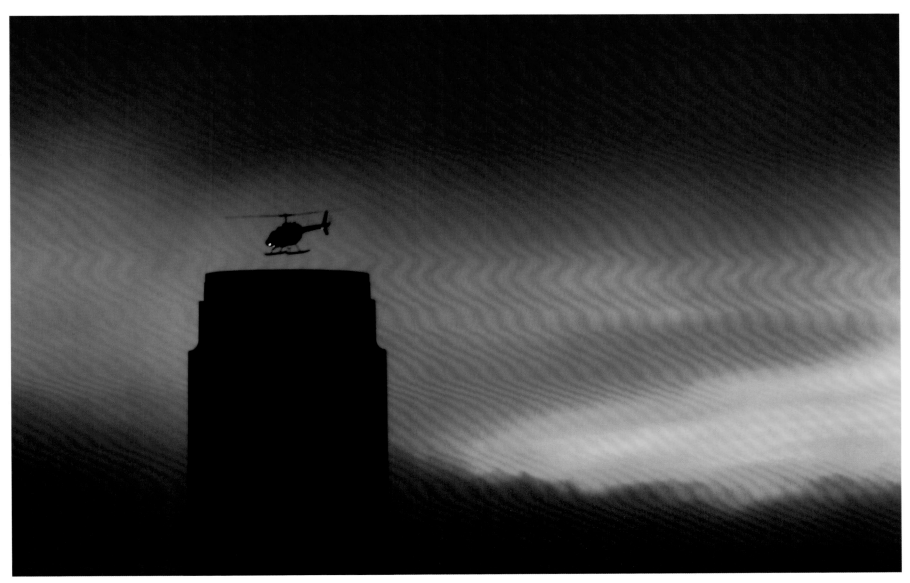

Sunrise, Coit Tower

"Golden city at the end of the sunset trail,

never coming even close to a million in population,

yet more renowned than places three times its size, and three times more fun."

Looking toward Mount Diablo

"At dusk-thou-art-to-dusk-returneth, the city still looks good, all pink and white and mauve and smoky. The setting sun softens the hard edges of Newtown West, and at cocktail time, a drink to the past makes the present less tense."

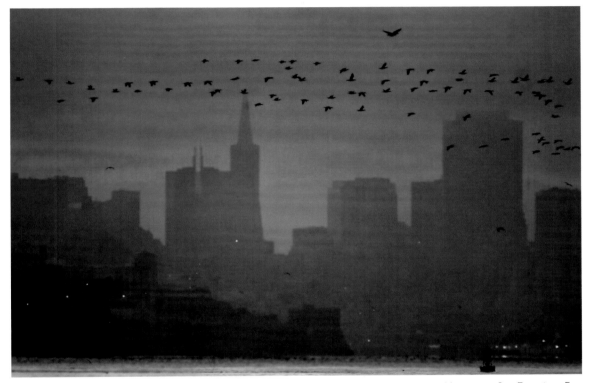

Skyline from Tiburon

Next page: San Francisco Bay

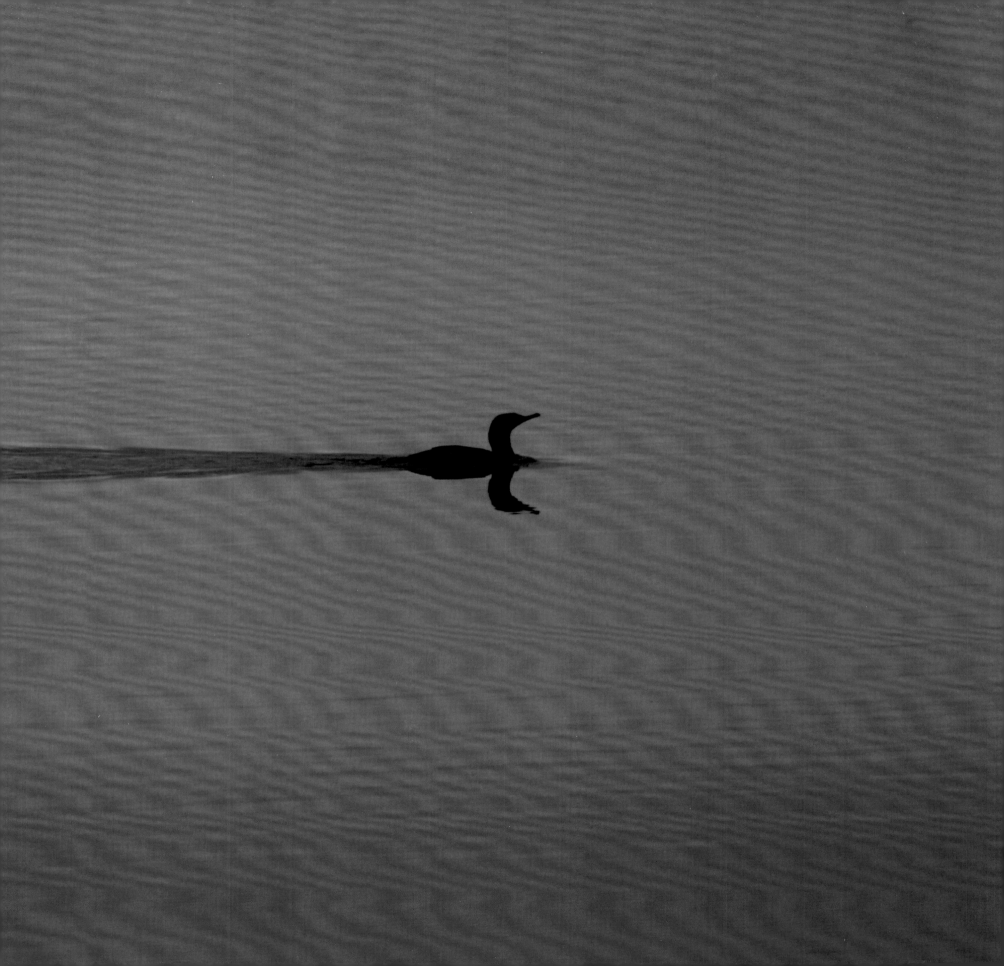

"A San Franciscan never ceases to marvel at so much variety in a small space."

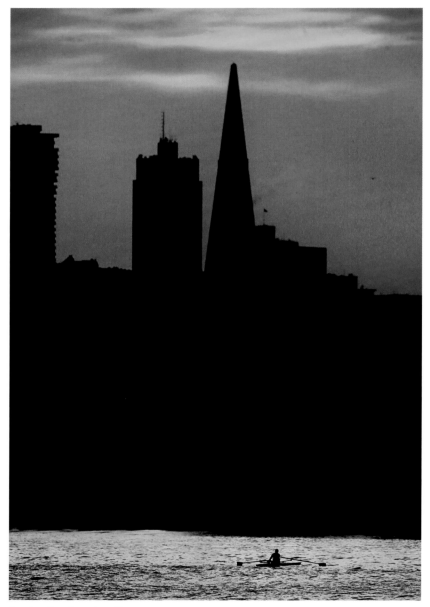

Sunrise, San Francisco Bay

"Blessed are those who are content to leave things more or less alone,
especially the things touched with a little bit of age
in this city that has lived so hard in so few years."

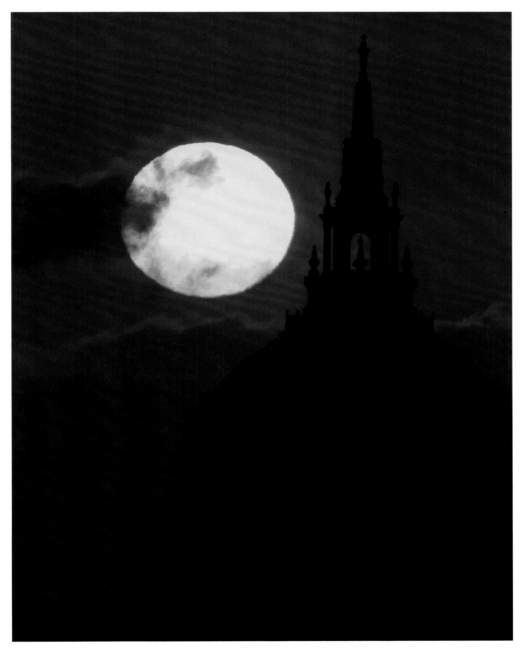

Sunrise, City Hall

"Beautiful day waning beautifully.
Delicate fingernail of a moon sailing serenely
over jeweled star in velvety sky."

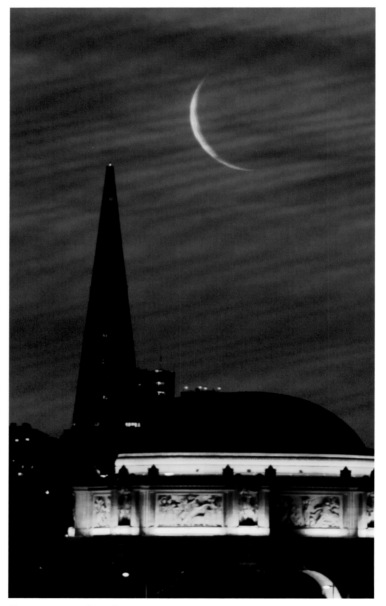

Crescent moon, Presidio

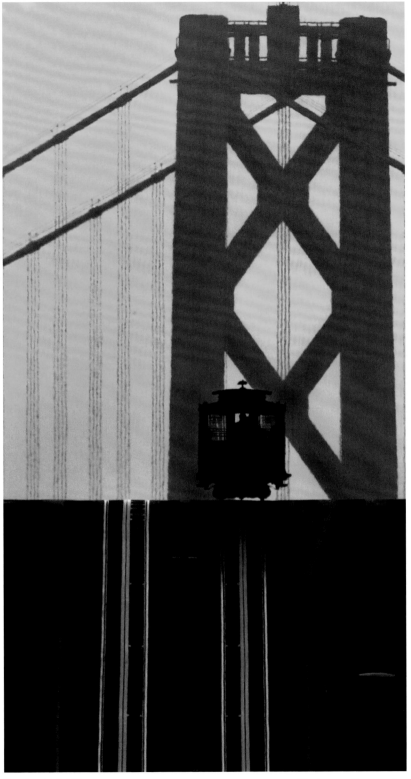

Sunrise, Nob Hill Next page: Fog, sunrise

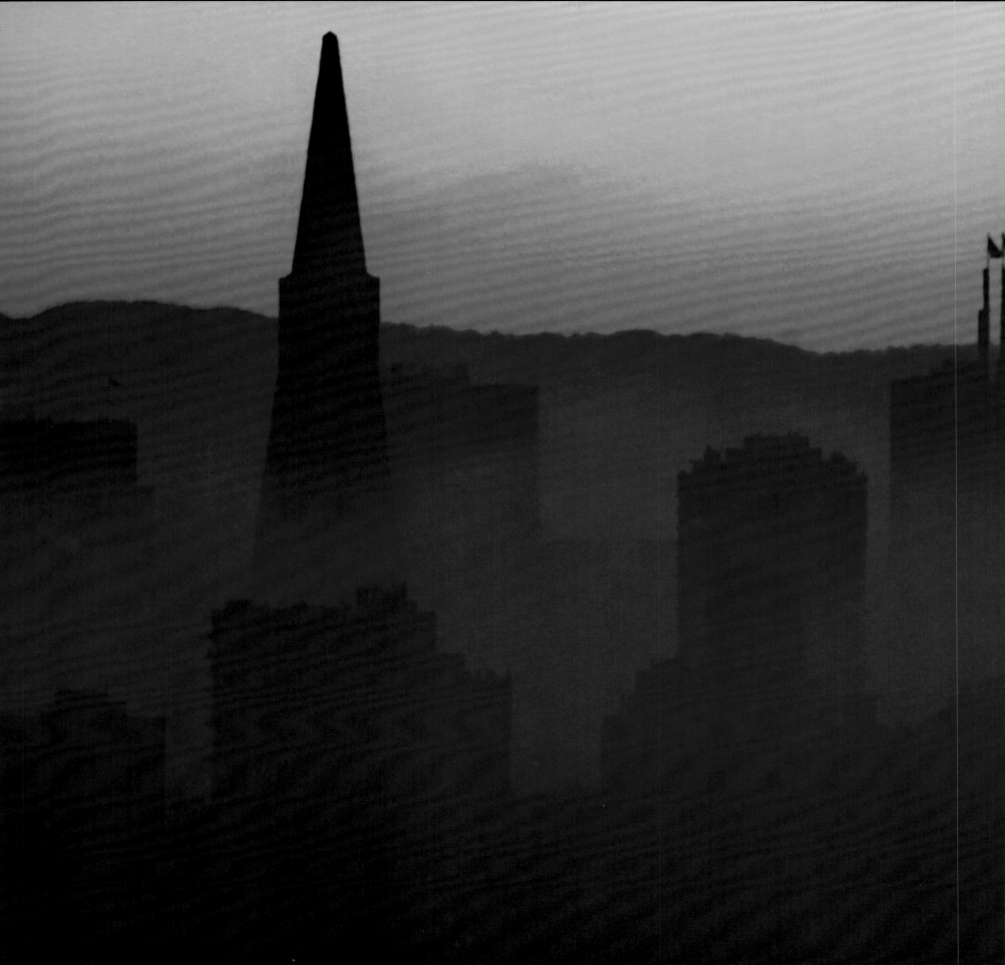

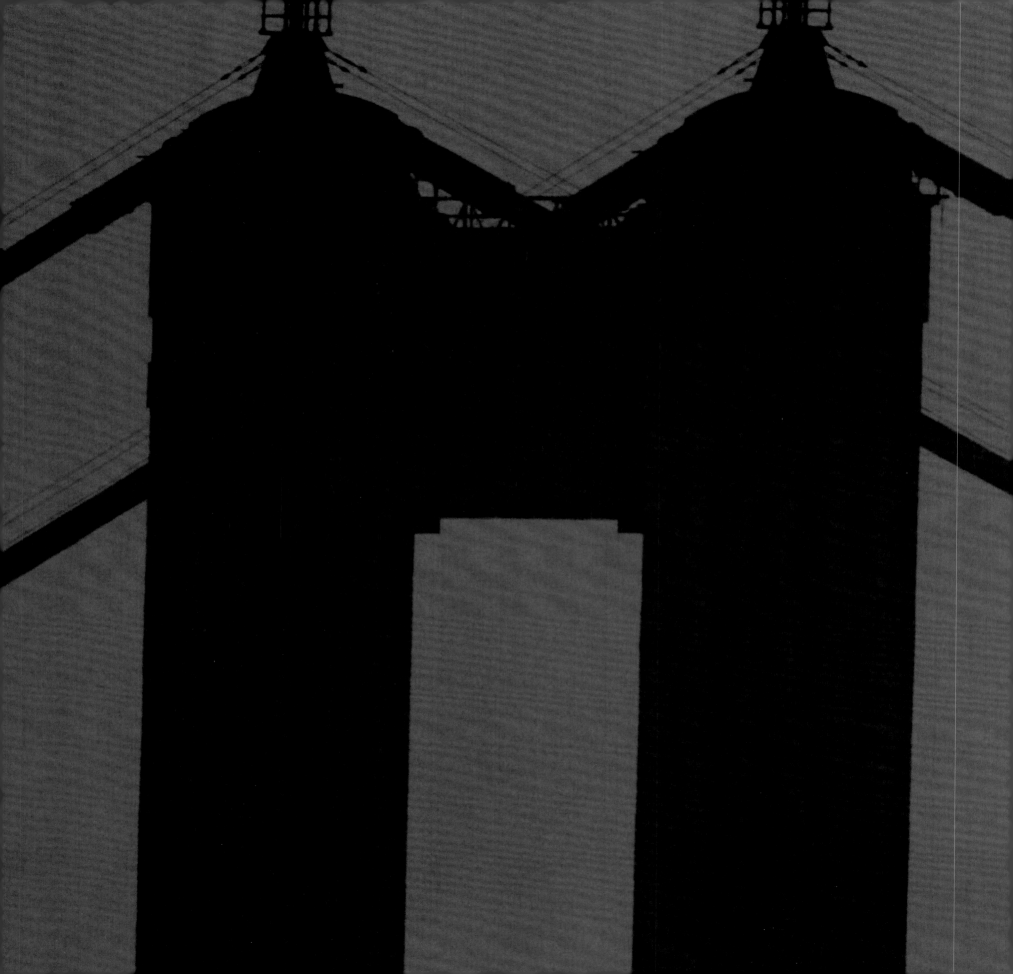

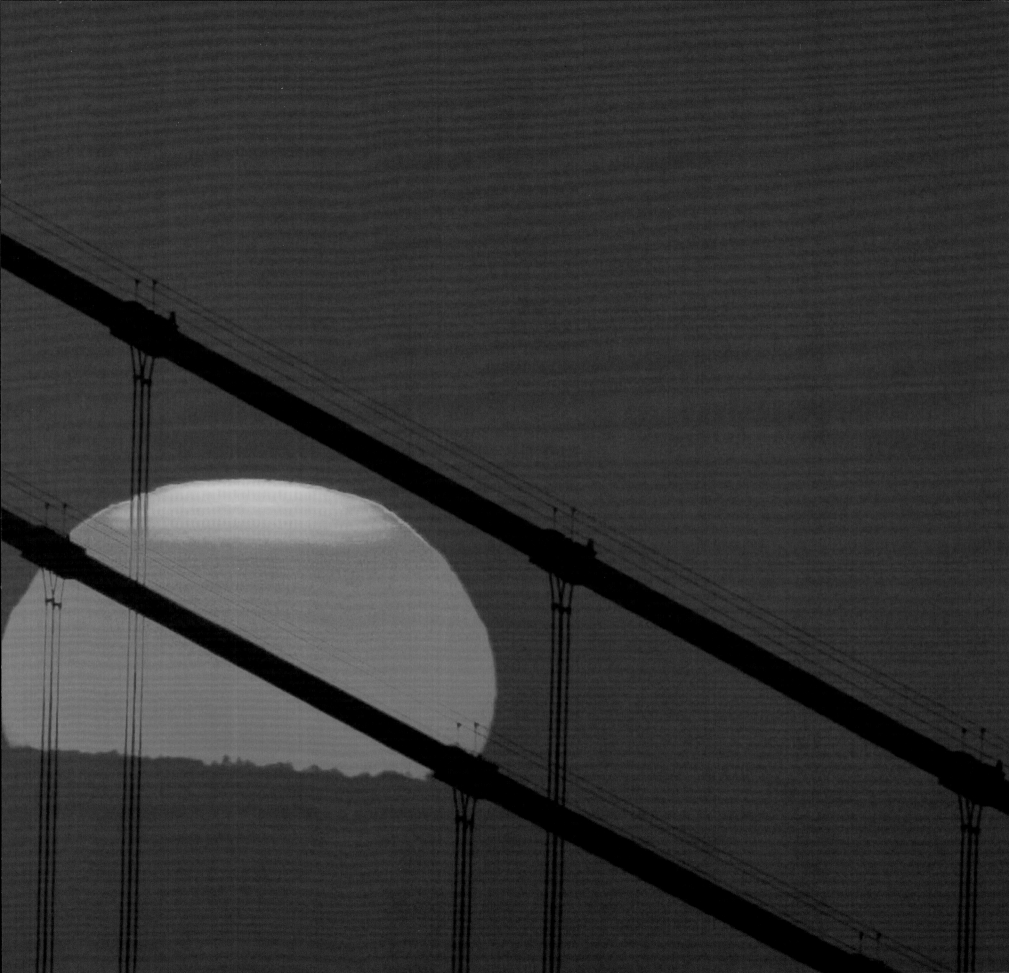

"The atmosphere was charged with mist and magic. The sun slept till noon.
The morning was for stockbrokers, scavengers, and getting back to your house from somebody else's for a shave."

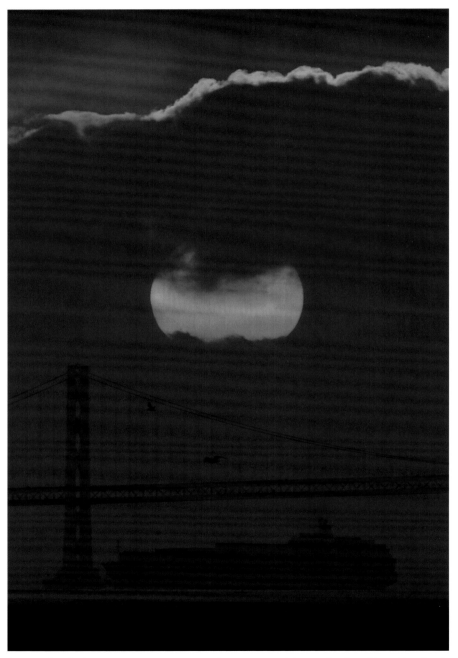

Sunrise, Bay Bridge Previous page: Morning fog from Marin Headlands

"It is almost impossible to explain the fabric of San Francisco without digging into the past; this is one of the city's strengths and hang-ups."

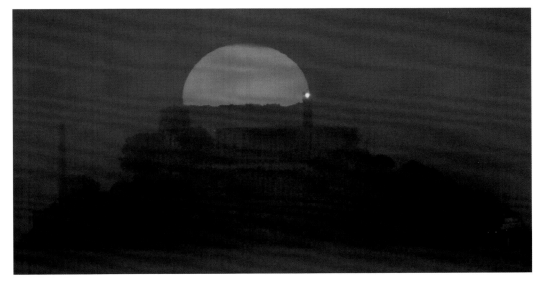

Sunrise, Alcatraz

"For a century, the tourists came to San Francisco for a thrill, a hill, a careless camaraderie, and an accessible bohemianism peculiar to this tiny marvel of a place."

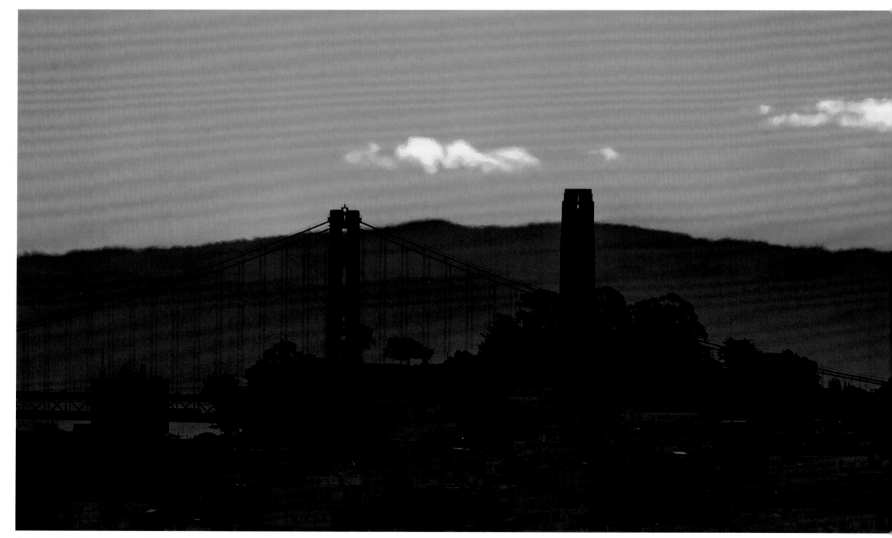

Sunrise, Coit Tower and Bay Bridge

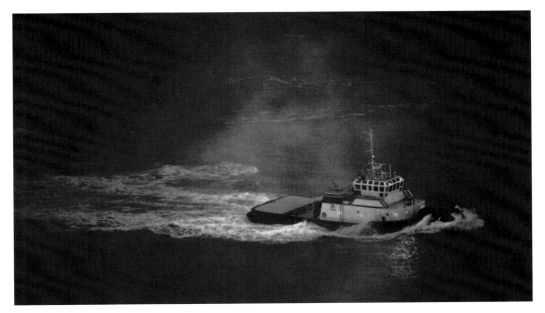

Tugboat, San Francisco Bay

"When you drive in on a Sunday evening after a hot day in the country and catch that first glimpse of the white fog racing in shreds — as though torn from a giant Kleenex box! — yes, flinging itself, Kleenex-like, through the cables of the world's greatest if too narrow bridge, you know why you live here."

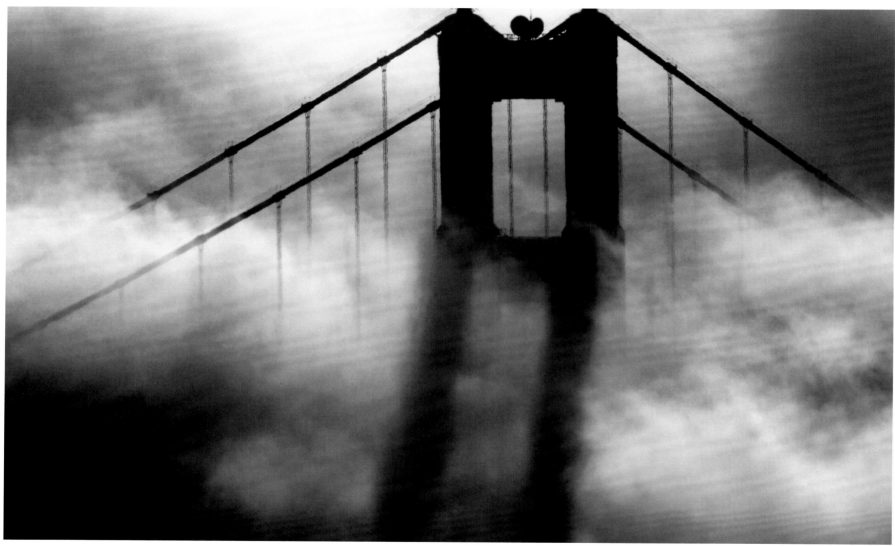

Shadow on fog, Golden Gate Bridge

"Let us consider the miracle that this city hasn't quite come apart at the seams.

There is time for one more dance, and then let's get serious."

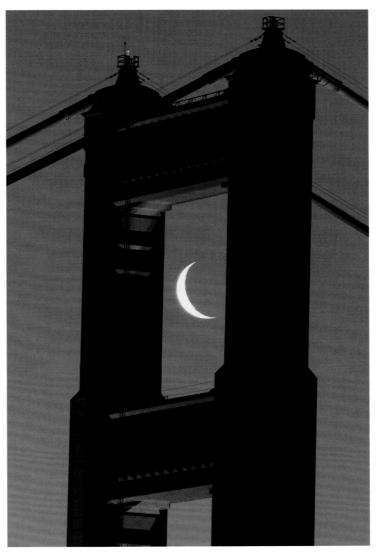

Crescent moon, Golden Gate Bridge

"A small city of strangers living cheek-by-jowl, with nothing in common except maybe an unspoken fascination with the sudden view, a vista never noticed before, a shared satisfaction at being part of All This."

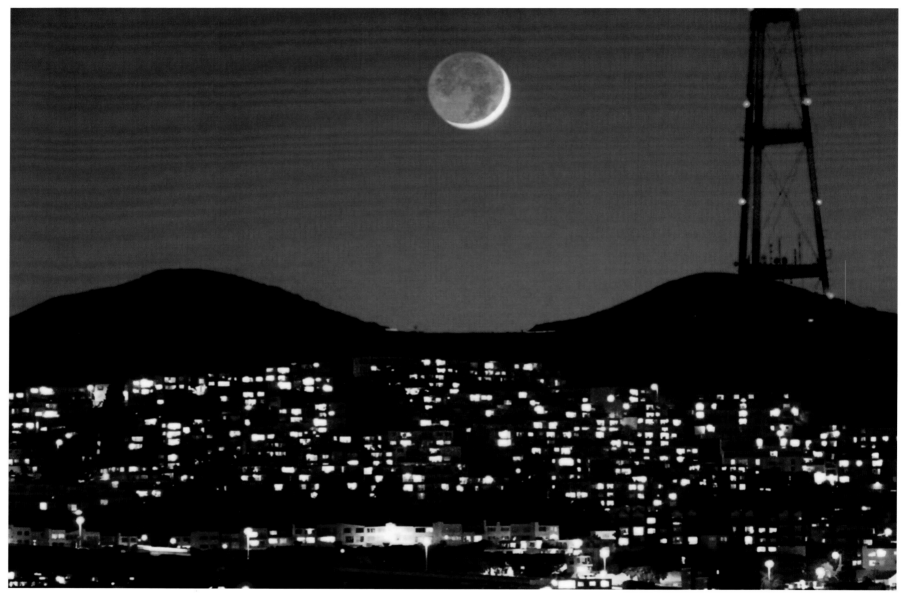

Twilight, Twin Peaks

"Dusk is the best time of day because the commuters are leaving town,

leaving the town to us who live and fight for its soul."

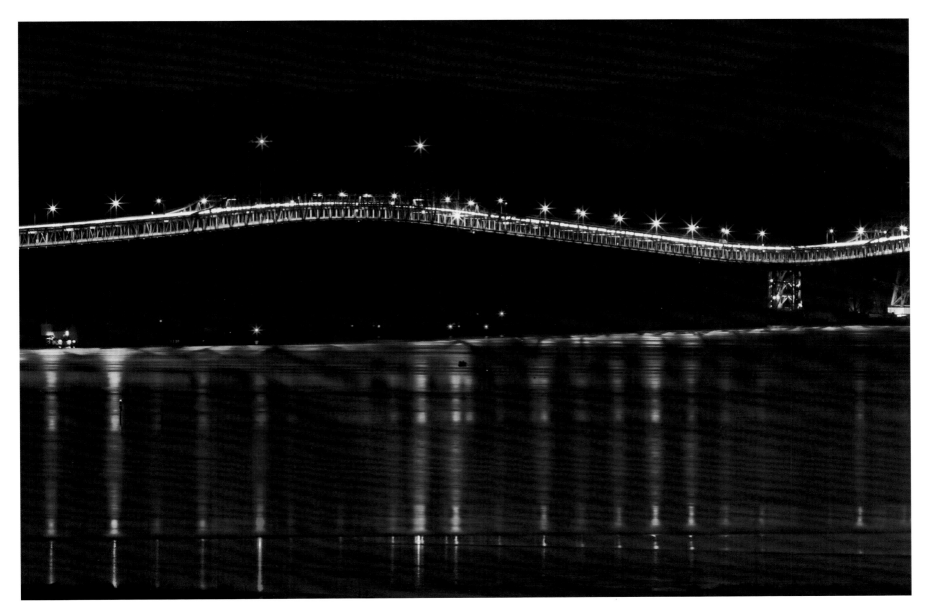

Richmond-San Rafael Bridge

"San Francisco: Its pulse beats everywhere."

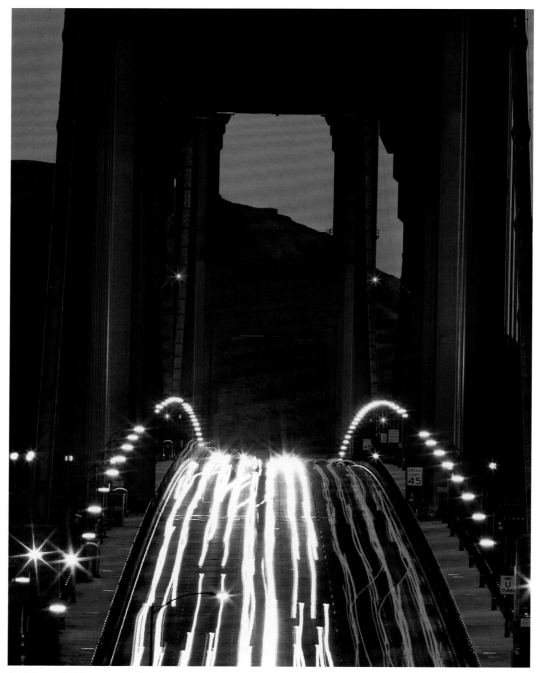

Rush hour, Golden Gate Bridge

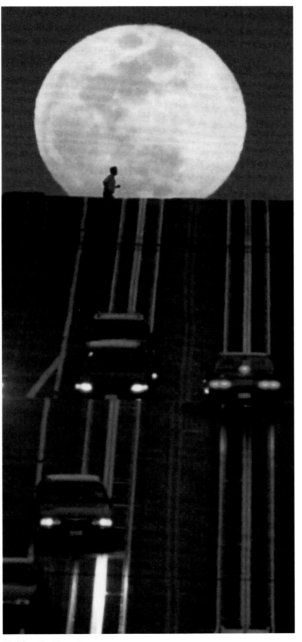

California Street

It's the glamorous alleys of North Beach at night - glamorous because the single street lamp casts a dramatic beam across each and sets the stage for a stark drama that is never enacted."

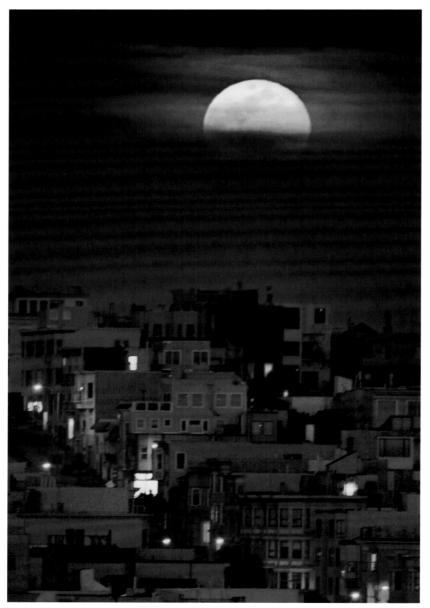

Full moon, North Beach

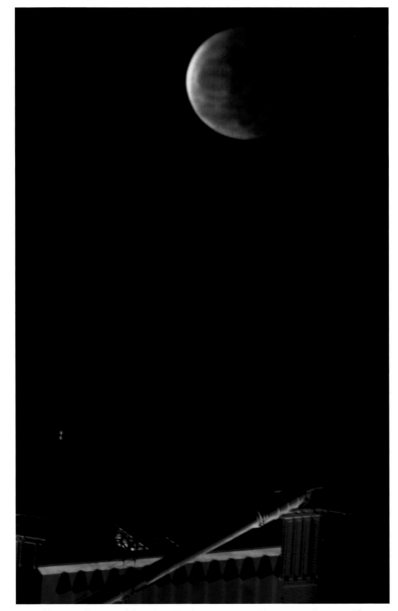

Partial lunar eclipse, Golden Gate Bridge Next page: Sunrise, Alcatraz

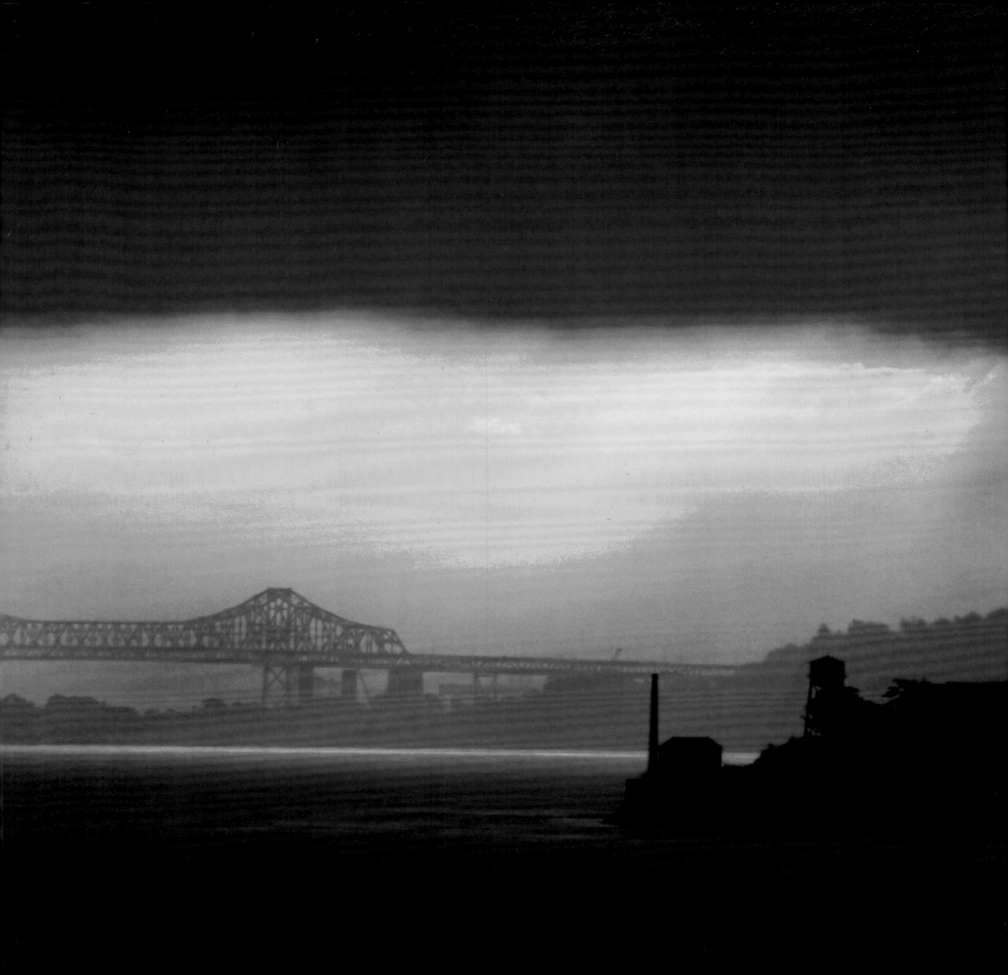

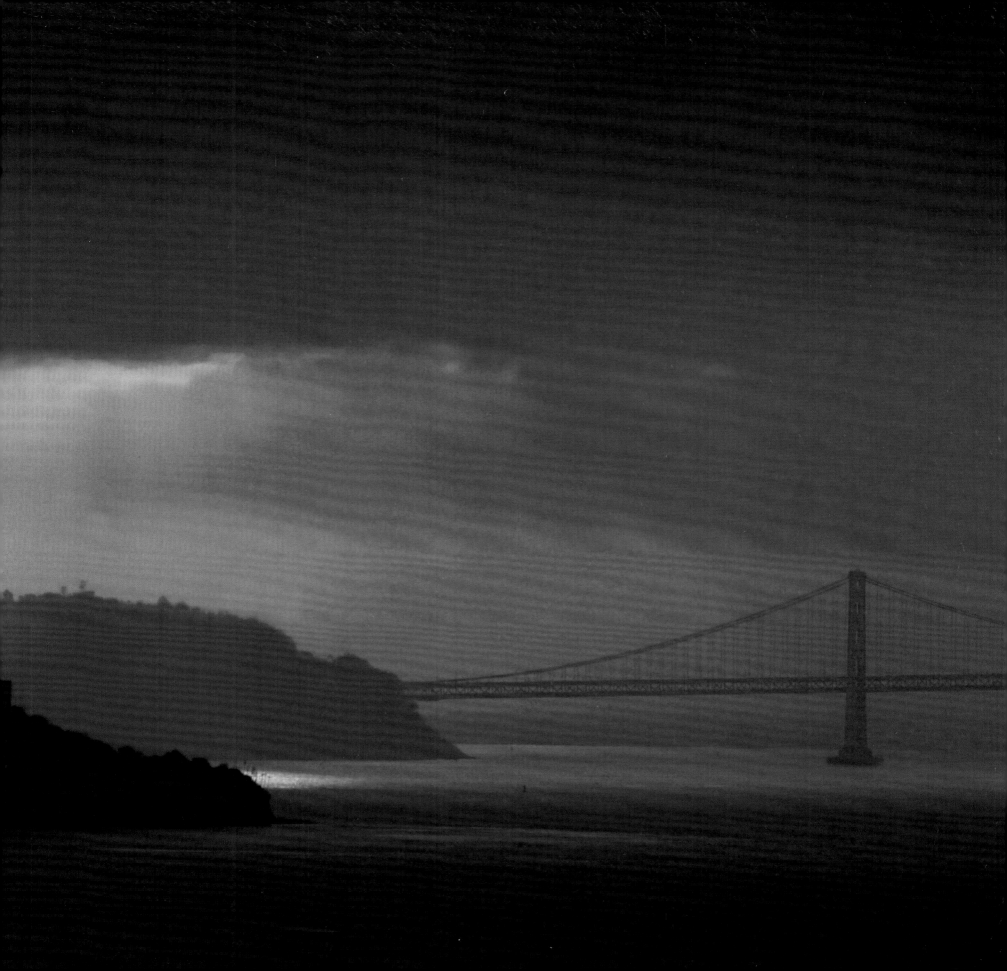

"A lot of us get fed up now and then with the city . . . but leaving it for keeps is something else again.

What would you do on your last day? . . . I think I would have to go to Coit Tower at dusk,

to look out on the bay and the hills and the lights coming on. Then . . . I would get drunk as hell."

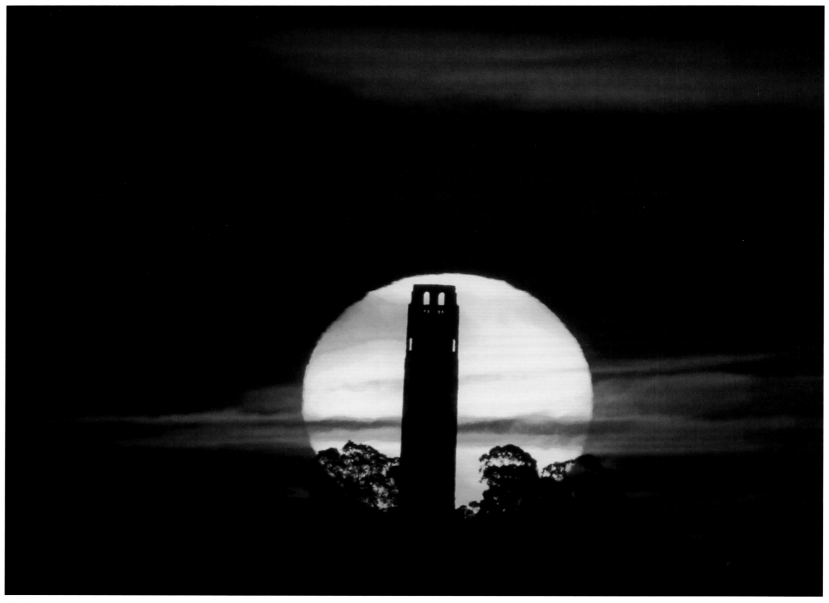

Coit Tower

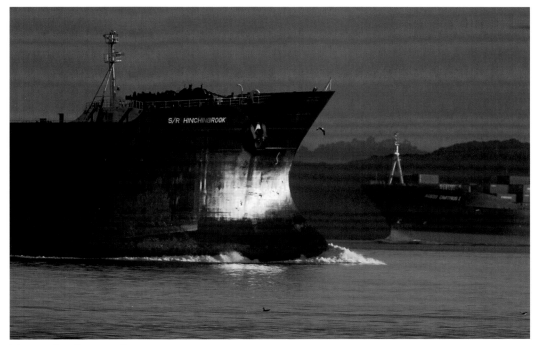

Morning, San Francisco Bay

"A real city, the kind they don't make any more.

Nowadays the so-called metropolitan areas are horridzontal,

stretching to infinity, a pall of malls."

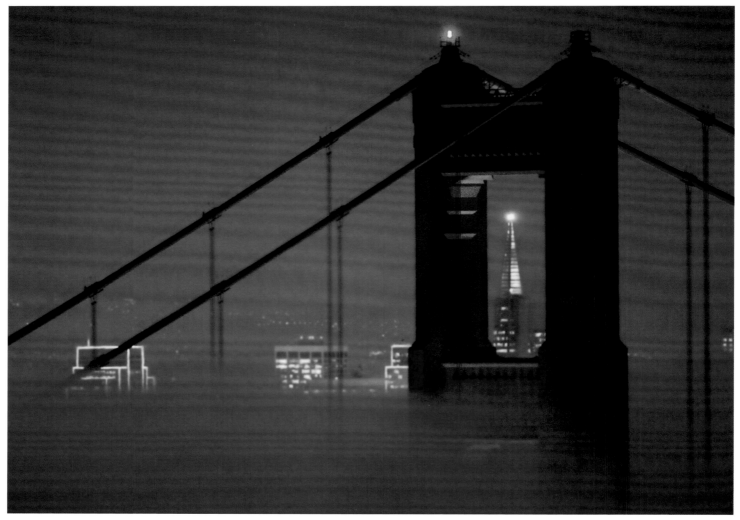

Fog, Golden Gate Bridge

"Can you see 'San Francisco' on a highway destination marker without feeling a slight lift, a tiny thrill?"

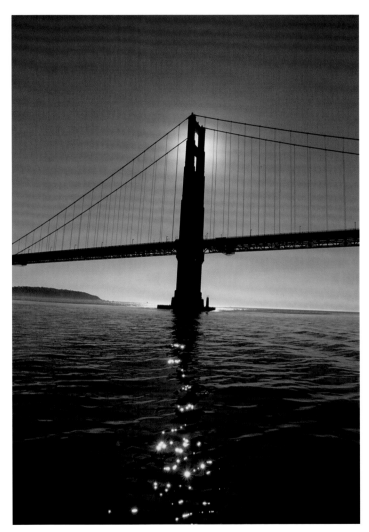

Golden Gate Bridge

"The city survives and even thrives. It began with gold in the hills

and it may end with dirt in the streets but who cares —

we are the fairest of them all and all the world loves a self-lover."

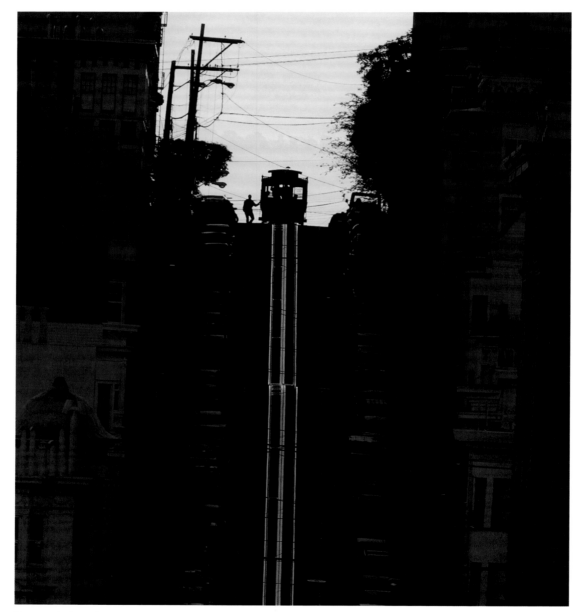

Sunrise, Jackson Street

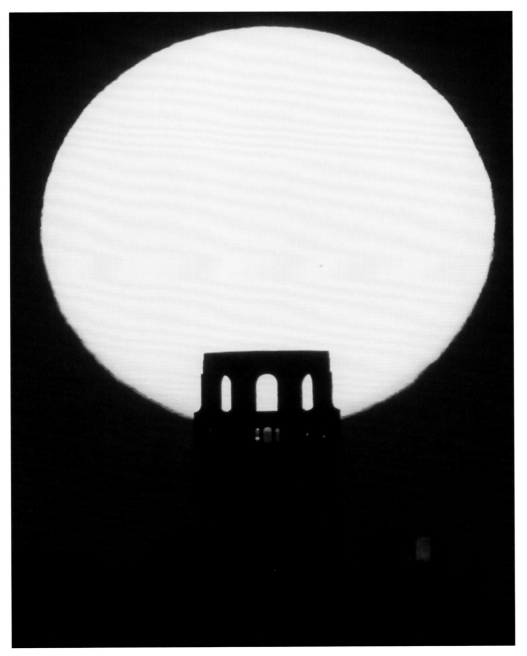

Sunrise, Coit Tower

"The great Carl Sandburg, sitting at Top o' the Mark, watching the fog inch through the Gate, and then confiding to a thoroughly confused waiter: 'It doesn't come in on little cat feet after all, does it?'"

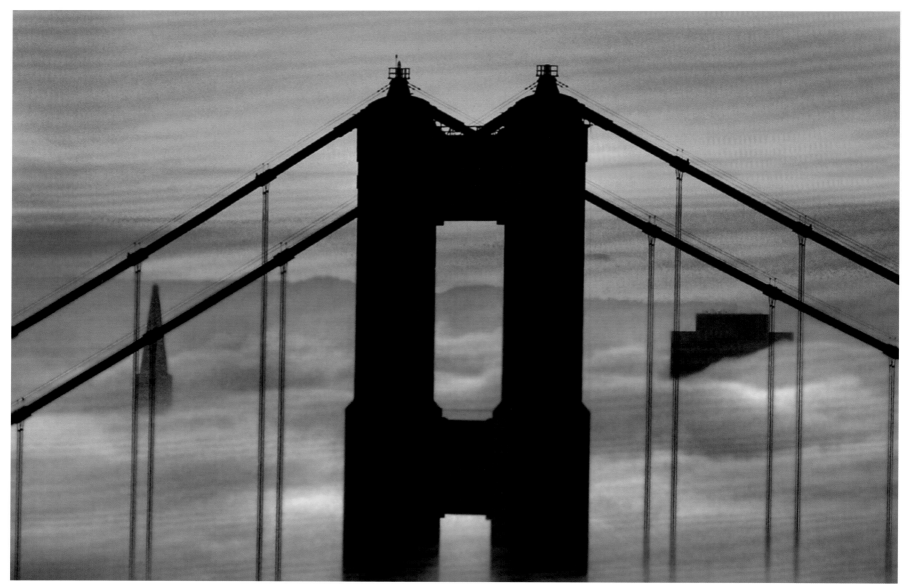

Fog, Golden Gate Bridge

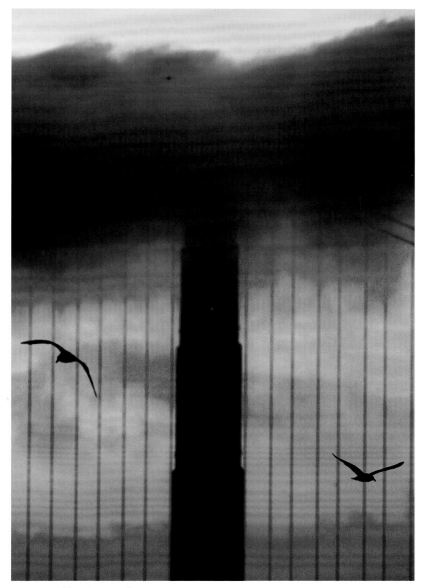

Sunset, Golden Gate Bridge

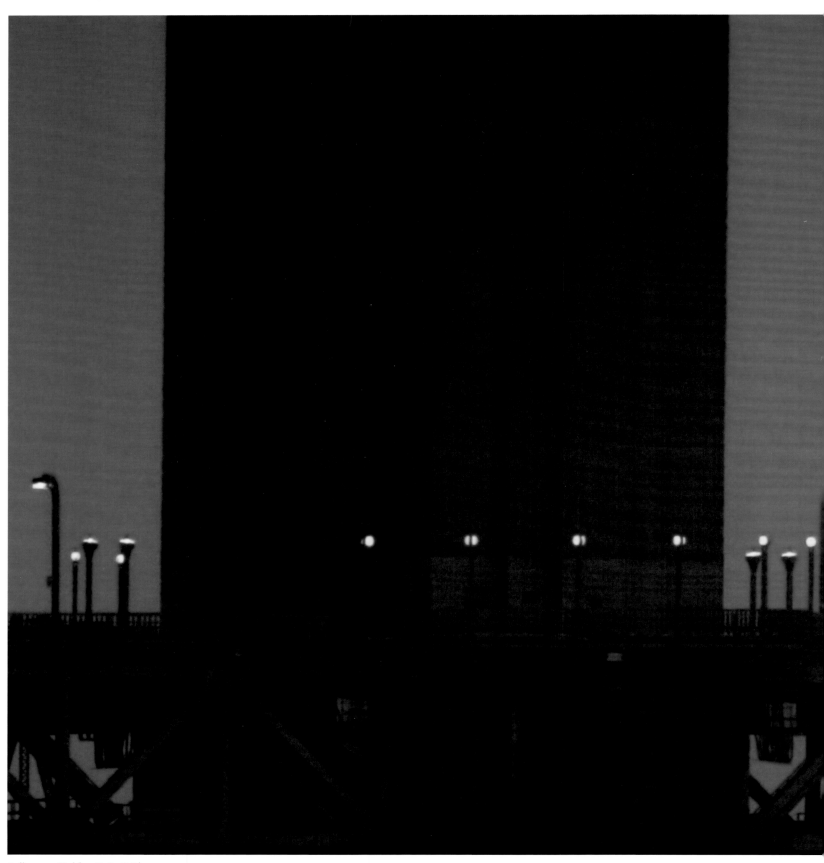

Full moon, Golden Gate Bridge

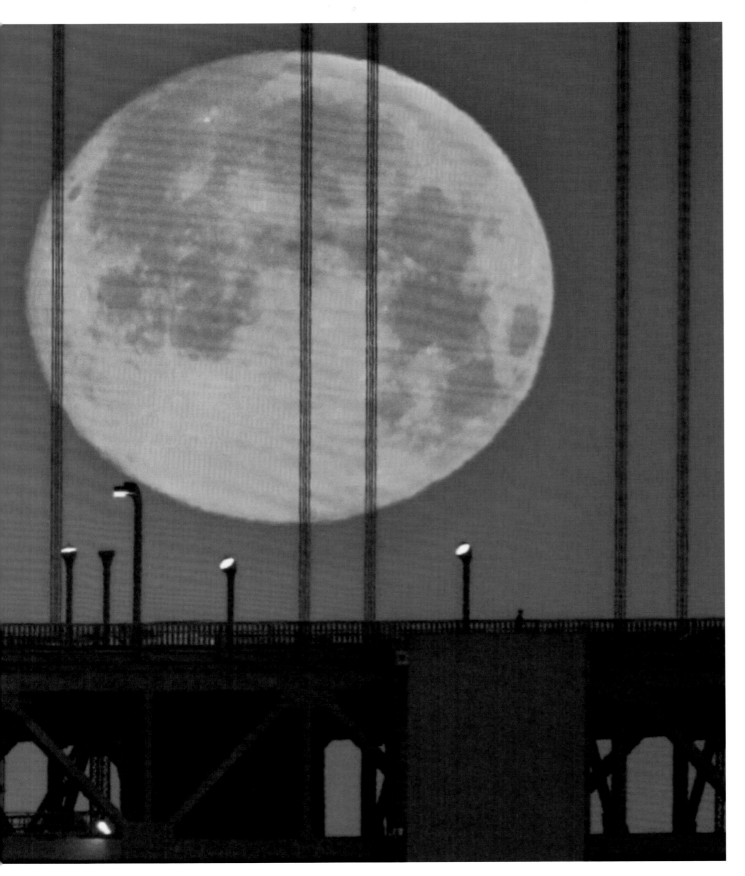

"It is best to gaze silently at times like this because as soon as you open your mouth about the beauties of San Francisco, especially under a full moon, some dreadful cliché drops out and squats there like a toad."

AFTERWORD BY FREDERIC LARSON

irst, some acknowlegements: I want to thank my friend, Trish Kiely, for her inspiration and help in editing this book, and Rich Simon, who educated me about lunar astrology. Thanks to *San Francisco Chronicle* colleagues: Editor Phil Bronstein for approving this book; Deputy Editor Narda Zacchino for her idea to publish it; Nanette Bisher and Heidi Swillinger for their vision; Kathleen Hennessy for her photo editing; Gary Fong for technical advice; Jennifer Asche for her meticulous proofreading; and Jay Johnson, Mark Lundgren, Leslie Guevarra, and John Storey for their invaluable help. Also, thanks to the staff at Sterling Publications for advice and patience: Charles Nurnberg, Rick Willet, Andrew Martin, Adria Dougherty, Yvette Wynne, Margaret LaSalle, Bette Gahres, and Leigh Ann Ambrosi; and to production liaisons Sally Liu at SNP Leefung and Josephine Yam at Colourscan.

On shooting the moon - and sun: when you set out to shoot the sun and the moon, there are bound to be challenges. In this book's cover photo, "Moon over Coit Tower," for example, the moon was in that exact spot for less than two seconds. Missing that shot — because of inclement weather or improper set-up — would have meant waiting another month at best. Missing a harvest moon would require a year's wait before it would appear in that same spot again. Patience and tolerance are absolute requirements of this craft. The exposure for every photograph in this book is listed in the index, but some are only approximate — I've composed this work over the last decade, and it's next to impossible to recall every exposure to the exact f/stop and shutter speed. Great moments in great light will win prizes. Some tips:

▶ If you don't have a light meter, just set your camera at f/16 and find the closest shutter speed to your ASA setting, and that will be your exposure for bright sun. Example: at ASA 400, your exposure for bright sun is f/16 at 1/500 of a second.

▶ The sun can permanently damage your eyes — don't look directly at it through the lens. Generally the sun is dimmer immediately upon rising, so get your shot then, but be careful. Looking directly at the sun could quickly end your photographic career.

▶ To tell where the full moon will rise, extend one arm directly toward the setting sun and extend the other arm 180 degrees in the opposite direction eastward. The moon will rise from that direction. If you want to be really accurate, buy a compass.

▶ Shooting the moon from below, such as in a valley or at the bottom of a hill, will make it appear larger. Also, the longer the lens, the bigger the moon.

▶ The moon moves quickly, so don't shoot slower than 1/60 of a second or you could get a blurry photograph. Buy a tripod and set your camera on a time-release to avoid any camera movements for long exposures.

▶ Twilight can be a magical time. Get your moon photograph just after the sun sets. Generally, you have about one hour of twilight at dawn and at dusk, and those are the ideal times for photographers.

▶ When shooting the moon after twilight, when the sun is reflecting off it, your exposure should be roughly the same as for daylight — 1/500 of a second at F16, ASA 400. Photographing the moon after twilight will be more difficult because a bright moon and a dark skyline make it next to impossible to balance the exposure.

A word about equipment: I am fortunate to work for a major metropolitan newspaper that provides me with the most modern — and expensive — equipment. In the early '90s, when I began shooting the moon, sun, and fog, I used a 35 mm Canon EOS-1N film camera with an array of very fast (large f-stop opening) Canon lenses. I shot then, as now, mostly with telephoto lenses ranging from 200 mm to 500 mm and could double the magnification by using a 2x teleconverter, allowing me to shoot greater than 1,000 mm. I use the sturdiest and most expensive tripod to hold heavy long lenses. I switched to digital photography in 1998. Most recently I have been using a Canon EOS-1D Mark II digital camera with a large digital file size. My photos are described in the following index:

1. CRESCENT MOON OVER CITY HALL
The moon sets on the horizon, and a wisp of fog passes over the moon, creating a spooky scene at City Hall around Halloween. 300mm lens, f4 at 1/30, ASA 800, color negative film.

2. CALIFORNIA STREET CABLE CAR
The morning sun lights up the California Street cable car in a bronze glow as it makes its way down to the Financial district. 500mm lens, f8 at 1/500, ASA 400, digital camera.

5. HEART SCULPTURE, UNION SQUARE
Getting this heart to appear to beat was a photographic challenge. I achieved this effect by setting the camera on a tripod with a short zoom lens and then racked the lens back and forth with a slow shutter speed. 24-35mm zoom lens, f22 at 1/15, ASA 200, digital camera.

6. SEA LION, FISHERMAN'S WHARF
A curious sea lion visits the docks of Fisherman's Wharf. 80-200mm zoom lens, f8 at 1/250, ASA 400, digital camera.

8-9. SUNRISE, MARIN HEADLANDS
This was one of those magical moments when I could get above the fog from the Marin Headlands during sunrise. 500mm lens, f8 at 1/1000, ASA 400, digital camera.

10. SUNRISE, GOLDEN GATE BRIDGE
Moments before sunrise, as I perched on a cliff overlooking the Golden Gate Bridge, the sky turned every color in the spectrum. 24-35mm zoom lens, f16 at 1/125, ASA 400, digital camera.

11. FOG, GOLDEN GATE BRIDGE
The Golden Gate Bridge lights illuminate upward as the incoming fog matches the color of the bridge. 500mm lens, f5.6 at 1/250, ASA 640, digital camera.

12. CRUISE SHIP THROUGH THE GOLDEN GATE
As I waited for the right light to photograph the sunset, a huge cruise ship steaming toward the Golden Gate Bridge filled my viewfinder. 500mm lens with 1.4x teleconverter, f8 at 1/500, ASA 400, digital camera.

13. TULIP AT PIER 39
A lone flower stands tall with the highest landmarks of San Francisco. 50mm macro lens, f16 at 1/60, ASA 200, digital camera.

14-15. NORTH BEACH SUNRISE
The steeples of Saints Peter and Paul Church and a tower of the Bay Bridge frame the North Beach district as dawn appears. 500mm lens, f8 at 1/250, ASA 400, digital camera.

16. SUNRISE AT TRANSAMERICA PYRAMID

Steam expelled behind the Transamerica Pyramid drifts past the rising sun, helping the composition of the photograph.

500mm lens with 1.4x teleconverter, f8 at 1/500, ASA 400, digital camera.

17. SEAGULL OVER PALACE OF FINE ARTS

As I photographed with a long lens from Fort Point, the palace appeared through the fog at the same time a seagull flew into my frame.

500mm lens, f5.6 at 1/500, ASA 400, digital camera.

18. SUNRISE TOPS GOLDEN GATE BRIDGE

The brilliant morning sun peeks over the south tower on its way over the Golden Gate Bridge, seen from the Marin Headlands, casting a yellow glow over the city skyline. 500mm lens, f22 at 1/2000, ASA 200, digital camera.

19. DETAIL, GOLDEN GATE BRIDGE

The Golden Gate Bridge shows off its texture during the morning twilight. 500mm lens, f22 at 1/250, ASA 400, digital camera.

20. HALF MOON BEHIND THE GOLDEN GATE BRIDGE CABLES

A line of cables and the setting half moon share a frame. 500mm lens with 1.4x teleconverter, f5.6 at 1/500, ASA 400, digital camera.

21. DOWNTOWN

Hovering in a helicopter over the city, I zoomed my lens backward with a slow shutter speed.

24-35mm zoom lens, f22 at 1/30, ASA 200, digital camera.

22. HALE-BOPP COMET OVER COIT TOWER

If you wanted to see the Hale-Bopp Comet flashing through the sky in 1996, you had to set your alarm clock for early morning. Shooting under Coit Tower brought Hale-Bopp back to Earth. To capture the comet, I had to use a tripod, bracket my exposure, and then cross my fingers. 50mm lens, f2.8 at 1/30, ASA 800, color negative film.

23. CABLE CAR GRIPMAN'S INSTRUCTIONS, CALIFORNIA STREET

A sign painted on the pavement on California Street near the Market Street cable car turntable instructs operators to "Let Go."

50mm lens, f16 at 1/125, ASA 400, digital camera.

24. POWELL STREET CABLE CAR

Hanging over the back of the cable car, I pointed my lens downward with a slow shutter speed to capture motion.

24mm lens, f/22 at 1/30, ASA 200, digital camera.

25. CABLE CAR TURNTABLE, POWELL STREET

With my tripod set up on a third-floor windowsill above the cable car turntable, I was able to get an overhead photograph of a cable car being spun. Slowing the camera shutter speed and zooming in at the same time helped achieve a feeling of movement.

24mm lens, f/22 at 1/15, ASA 200, digital camera.

26. POWELL STREET CABLE CAR

I positioned myself at the rear of a cable car, slowed down my shutter speed, then fired off my electronic flash, which created a blurred effect when the conductor yanked vigorously on the brake lever. 24mm lens, f/22 at 1/30, ASA 200, digital camera.

27. FERRY BUILDING THROUGH STEAM ON MARKET STREET

Steam rising from a manhole cover distorts the Ferry Building and the cables for the trolleys on Market Street.

500mm lens, f8 at 1/250, ASA 400, digital camera.

28. GOLDEN GATE BRIDGE REFLECTED IN RAINDROPS

A colleague, Gary Fong, introduced me to this technique, in which you use a macro lens to magnify a storytelling image. This image was photographed through the car windshield. 50mm macro lens, f8 at 1/250, ASA 400, digital camera.

29. VIEW FROM GOLDEN GATE BRIDGE NORTH TOWER

Being fortunate enough to ride the elevator to the top of the north tower of the Golden Gate Bridge gave me a rare perspective. 80-200mm zoom lens, f11 at 1/250, ASA 400, digital camera.

30. OCEAN BEACH

Sandpipers scurry away from the surf at Ocean Beach. The photograph was taken from the seawall near the Cliff House. 500mm lens, f8 at 1/1000, ASA 400, digital camera.

31. DESIGN BY WAVES, OCEAN BEACH

Overlooking Ocean Beach — the receding tide creates an interesting shape. 500mm lens, f8 at 1/250, ASA 400, digital camera.

32-33. BEACH AT CRISSY FIELD, PRESIDIO

I was drawn to this scene because the long shadows made the waves look three-dimensional. 500mm lens, f8 at 1/500, ASA 640, digital camera.

34-35. BAKER BEACH

I mounted my camera on a tripod near the water's edge surrounded by oncoming waves. I set my shutter on a slow speed with a self-timer. I succeeded in capturing the photograph but lost several years off my life by putting my camera in harm's way. 24-35 zoom lens, f22 at 1/30, ASA 200, digital camera.

36. PARASURFING, SAN FRANCISCO BAY

A bird's-eye view from a helicopter peering straight down on a parasurfer on the bay. 24-35mm zoom lens, f8 at 1/1000, ASA 400, digital camera.

37. OIL ON CALIFORNIA STREET CABLE CAR TRACKS

Rainwater and oil on a cable car rail give the scene style as the sun reflects through the mixture. 50mm lens, f16 at 1/125, ASA 200, digital camera.

38. HOLIDAY LIGHTS, DOWNTOWN

The Transamerica Pyramid and surrounding buildings are lit up in December. 300mm lens, f4 at 1/30, ASA 800, color negative film.

39. FULL MOON, TRANSAMERICA PYRAMID

One of my first moon photographs, taken in 1993 on a foggy evening from Russian Hill. 300mm lens, f4 at 1/60, ASA 800, color negative film.

40. SKYLINE, GOLDEN GATE BRIDGE

Shooting back at the city from Point Bonita Lighthouse. The San Francisco skyline appears to sit perfectly on the Golden Gate Bridge. 500mm lens, f8 at 1/250, ASA 400, digital camera.

41. SUNRISE, MARIN HEADLANDS

The rising sun hugs the sides of the south tower of the Golden Gate Bridge while the city stays in fog. 500mm lens with 1.4x teleconverter, f5.6 at 1/250, ASA 400, digital camera.

42. SILHOUETTE

The San Francisco skyline was heavily backlit, which helped achieve a great contrast of colors, orange and black.
500mm lens, f8 at 1/250, ASA 640, digital camera.

43. FULL MOON, COIT TOWER

I used a compass and a moon chart to plot the point at which the moon would pass over and top Coit Tower just minutes after moonrise. The incoming fog helped tone down the bright moon and match the sky's color of burnt orange to the hue of the moon.
400mm lens, f4 at 1/60, ASA 800, color negative film.

44. EARTHSHINE MOON

The Earth reflects enough light from the sun to show the complete outline of the moon as it slowly sets behind the peak of Mount Tamalpais. Shot from Mill Valley. 500mm lens, f/5.6 at 1/30, ASA 800, digital camera.

45. CRESCENT MOON, SUTRO TOWER

The crescent moon sits between the highest antennas of Sutro Tower on Twin Peaks, almost as though resting among ships' masts.
400mm lens, f4 at 1/60, ASA 800, color negative film.

46. MOONSET, HYDE STREET

After an exhausting, early-morning search for a landmark, I came upon an eerie tree that helped complement the moon.
500mm lens, f8 at 1/250, ASA 400, digital camera.

47. MOONRISE, PACIFIC HEIGHTS

The sun illuminates the windows of a Pacific Heights mansion at the same time the moon rises. This photograph was taken from the Presidio looking toward Pacific Heights. 500mm lens, f5.6 at 1/250, ASA 400, color negative film.

48-49. SUNBEAMS, BAY BRIDGE

After several days of rain, a break in the clouds at sunrise lets through a shaft of light that reflects upon the bay as a tanker passes under the bridge. 500mm lens, f5.6 at 1/250, ASA 400, digital camera.

50-51. MORNING SWIM, SAN FRANCISCO BAY

Much to my surprise, I caught an early-morning swimmer off the shores of Sausalito in the wintertime.
300mm lens, f5.6 at 1/250, ASA 640, digital camera.

52. SUNSET, POINT BONITA

Having been denied access to the west side of the Golden Gate Bridge, I went underneath and found an angle from which to shoot the sun setting behind Point Bonita's lighthouse. 500mm lens, f8 at 1/250, ASA 400, digital camera.

53. RISING SUN, COIT TOWER

After weeks of failed attempts to get the sun on top of Coit Tower at sunrise, I finally captured the moment just as a jet flew into the frame. The top portion of the sun was four stops overexposed, but the fog diffused the lower portion.
500mm lens with 2x teleconverter, f/11 at 1/4000, ASA 200, digital camera.

54. FOG, GOLDEN GATE BRIDGE

Appearing to be a black-and-white photograph, this view of the tower was shot in color, but the fog stripped out any signs of hue from the skyline. 80-200mm zoom lens with 1.4x teleconverter, f11 at 1/500, ASA 400, digital camera.

55. FOG, BAY BRIDGE
Fingers of clouds help frame the Bay Bridge from the Marin Headlands. During the early morning just after sunrise, the fog cleared the way to view the bridge. 500mm lens, f/8 at 1/500, ASA 400, digital camera.

56-57. FOG, GOLDEN GATE BRIDGE
An hour after morning twilight, the fog descends enough to reveal the tips of both towers of the Golden Gate Bridge. 80-200mm zoom lens with 1.4x teleconverter, f11 at 1/500, ASA 200, digital camera.

58. FOG, PIER SEVEN
A magical morning in San Francisco as the lampposts of Pier Seven dissolve into the dense fog. 500mm, f5.6 at 1/250, ASA 400, digital camera.

59. ALCATRAZ FROM RICHARDSON BAY BRIDGE
This photograph of Alcatraz and the Bay Bridge shot from under the Richardson Bay Bridge in Mill Valley is totally devoid of color. 500mm lens, f8 at 1/250, ASA 400, digital camera.

60. GOLDEN GATE BRIDGE
The Golden Gate Bridge is reflected in raindrops on my car's windshield. 24mm lens, f4 at 1/125, ASA 400, digital camera.

61. WET STREETS OF NORTH BEACH
A couple on a morning stroll through North Beach after the rains have stopped. 500mm lens, f8 at 1/250, ASA 400, digital camera.

62. LOMBARD STREET
The crooked street took a twist as I tilted my camera to match the terrain. 500mm lens with a 1.4x teleconvertor, f8 at 1/500, ASA 400, digital camera.

63. CABLE CAR, CALIFORNIA STREET
A popular technique used by photographers is to tilt your camera to match the foreground, making the background appear slanted. 24mm lens, f/8 at 1/1000, ASA 200, digital camera.

64. SAILING SHIP *BALCLUTHA*, HYDE STREET PIER
Two men gaze at the full moon from a yardarm of the 109-year-old sailing vessel the *Balclutha*, which is moored at the foot of Hyde Street. 300mm lens, f5.6 at 1/250. ASA 400, color negative film.

65. SUNSET SURFING
A surfer off Rodeo Cove at Fort Cronkhite is backlit by the setting sun, making the subject appear as if he were surfing around liquid fire. 500mm lens, f5.6 at 1/1 000, ASA 640, digital camera.

66. PIER NEAR FORT POINT
Sharing the same pier beneath the Golden Gate Bridge at sunrise, I could not help but take a photograph of this upwardly mobile group. 24-35mm zoom lens, f5.6 at 1/1000, ASA 640, digital camera.

67. SEAGULL, GOLDEN GATE BRIDGE
A gull flies along the stern of a bay cruise boat after touring the Golden Gate Bridge. 24mm lens, f8 at 1/1000, ASA 400, digital camera.

68. SUNRISE, CALIFORNIA STREET
A backlit California Street at dawn turns the scene to sepia.
500mm lens with 1.4x teleconverter, f5.6 at 1/1000, ASA 400, digital camera.

69. CALIFORNIA STREET
Shooting from about half a mile away with a long lens, I captured a California Street cable car waiting for its passengers.
500mm lens with 2x teleconverter, f/8 at 1/1000, ASA 400, digital camera.

70. MOONRISE, WILLIE MCCOVEY COVE
My photographic intention was to have a baseball (the full moon) hit into San Francisco Bay by Willie McCovey (the statue).
400mm lens, f4 at 1/60, ASA 800, digital camera.

71. FULL MOON, CANDLESTICK PARK
A non-photographic tidbit: did you know that when there was a full moon on game day, the San Francisco 49ers usually were victorious? 400mm lens, f5.6 at 1/60, ASA 800, color negative film.

72-73. SKYLINE
San Francisco wakes up in the morning as seen from the Golden Gate Bridge.
80-200mm zoom lens, f8 at 1/250, ASA 400, digital camera.

74. FIREWORKS, SKYLINE
An extremely calm evening helped me steady my camera long enough to obtain a long exposure of fireworks on Pier 39. This city skyline was photographed from the Sausalito waterfront. 500mm lens, f5.6 at 1/60, ASA 800, digital camera.

75. TWILIGHT, ALCATRAZ
A rare still evening on the bay brought great photographic opportunities that enabled me to slow my shutter speed down for a special effect. 300mm lens, f22 at 5 seconds, ASA 200, digital camera.

76. CLOUDS, HYDE STREET
A band of ominous rainclouds obscures the rising sun, making for a dramatic dawn. 500mm lens, f22 at 1/125, ASA 400, digital camera.

77. FULL MOON, COIT TOWER
My patience was thoroughly tested trying to find an angle to photograph the full moon over or near Coit Tower. Buildings and trees marred any clear angle. Persistence prevailed after I carried my long lens and tripod through the back streets of Russian Hill.
500mm lens, f5.6 at 1/125, ASA 400, digital camera.

78. TOTAL LUNAR ECLIPSE, TRANSAMERICA PYRAMID
A total lunar eclipse brings out all the tripods and lunatics. The hardest task was chasing around the city finding a clear view without telephone wires in my frame. As it happened, the moment of the eclipse came at an awkward time. With my tripod, lens and camera ready, I double-parked, jumped out of my car in traffic, and got the shot. 500mm lens, f56 at 1/60, ASA 800, digital camera.

79. EARTHSHINE MOON, GOLDEN GATE BRIDGE
When the Earth reflects back on the moon, you get "earthshine," which helps illuminate a dark photograph of the Golden Gate Bridge.
300mm lens, f4 at 1/60, ASA 800, color negative film.

80. MOON MEETS EARTH OBJECTS, HYDE STREET
The moon stands out at morning twilight with three very earthly objects — roof vents.
500mm lens, f11 at 1/250, ASA 800, digital camera.

81. SUNRISE, COIT TOWER
Bands of fog intrude upon a sun-silhouetted Coit Tower as a helicopter passes by.
500mm lens, f8 at 1/500, ASA 640, digital camera.

82. TREE, MOUNT DIABLO
My attempt to line up the sun rising over Mount Diablo from Hyde Street was aborted by a conifer that fit perfectly inside the mountain's peak. 500mm lens, f8 at 1/250, ASA 400, digital camera.

83. SKYLINE FROM TIBURON
Shot from the wetlands off Tiburon, a flock of birds accentuates an overcast sunrise.
200mm lens, f/5.6 at 1/250, ASA 400, digital camera.

84-85. SAN FRANCISCO BAY
A lone cormorant leaves a wake in the pink, blue, and silvery bay at sunrise. 500mm lens, f16 at 1/250, ASA 400, digital camera.

86. SUNRISE, SAN FRANCISCO BAY
A silhouetted skyline dwarfs a lone rower at sunrise. 500mm lens, f8 at 1/250, ASA 400, digital camera.

87. SUNRISE, CITY HALL
Standing in the middle of Fulton Street, I tried to line up the rising sun with City Hall and was fortunate enough to get a wisp of fog to diffuse the bright sun. 500mm lens, f8 at 1/1000, ASA 400, digital camera.

88. CRESCENT MOON, PRESIDIO
The crescent moon was predicted to rise over the skyline during the morning twilight. I set up a tripod with my camera on a self-timer after finding a place at Crissy Field where the wind would not affect camera movement and waited for the moon to rise over the Transamerica Pyramid. 500mm lens, f5.6 at 1/30, ASA 800, digital camera.

89. SUNRISE, NOB HILL
There are just a few times a year that the rising moon and sun line up with the same angle as the streets of San Francisco. On these days, you can look eastward down most streets of the city and view the sun or the moon rising in your frame. Here, the shot was taken before the actual orb of the sun came into view. 500mm lens with 2x teleconverter, f/8 at 1/1000, ASA 400, digital camera.

90-91. FOG, SUNRISE
The morning fog hugs the skyline while the sun lights up the eastern golden sky viewed from the Marin Headlands.
500mm lens, f8 at 1/250, ASA 400, digital camera.

92-93. MORNING FOG, MARIN HEADLANDS
The early-morning was engulfed in a heavy mist, almost transparent, which helped my image by turning the bulk of the frame totally gray with a bright red fireball squeezed between the Golden Gate Bridge cables.
500mm lens with 1.4x teleconverter, f5.6 at 1/60, ASA 400, digital camera.

94. SUNRISE, BAY BRIDGE
The morning sun blasts its way through dark rainclouds, brightening up the skyline over the Bay Bridge.
500mm lens, f/8 at 1/125, ASA 400, digital camera.

95. SUNRISE, ALCATRAZ
Reading a compass the previous night, I calculated that the sun would rise behind Alcatraz. In the morning, a perfectly balanced fireball was diffused through a fine, low-lying mist of fog. 500mm lens, f5.6 at 1/125, ASA 400, digital camera.

96. SUNRISE, COIT TOWER AND BAY BRIDGE
 Standing mid-span on the Golden Gate Bridge, I found a vantage point to capture a morning sky before the rising sun completely silhouetted Coit Tower and the south tower of the Bay Bridge.
500mm lens with 1.4x teleconverter, f5.6 at 1/150, ASA 400, digital camera.

97. TUGBOAT, SAN FRANCISCO BAY
A tugboat makes its way through the foggy mist and rough seas of the "potato patch" just outside the Golden Gate Bridge at dawn.
500mm lens with 1.4x teleconverter, f5.6 at 1/250, ASA 400, digital camera.

98. GOLDEN GATE BRIDGE
The north tower of the Golden Gate Bridge slowly became clear through the dense fog at the same time the sun cast a shadow of the bridge onto the fog. Photographed in color, the image appears to be in black-and-white.
80-200mm zoom lens with 1.4x teleconverter, f11 at 1/500, ASA 200, digital camera.

99. CRESCENT MOON, GOLDEN GATE BRIDGE
My aim was to capture the moon setting and frame it inside the south tower of the Golden Gate Bridge. I had to hike down a dark, narrow path on a cliff of the Marin Headlands, plant my tripod, and hope that I was awake enough to set my time release, set the correct exposure, and choose the correct focal length to frame the moon. 300mm lens, f4 at 1/30, ASA 800, digital camera.

100. TWILIGHT, TWIN PEAKS
Shooting the moon setting in between Twin Peaks is a challenge. With just 4 percent of the moon visible during twilight, earthshine helped complete the moon's shape. 400mm lens, f4 at 1/60, ASA 400, color negative film.

101. RICHMOND-SAN RAFAEL BRIDGE
An extremely calm bay offered a photographic opportunity to capture colored spikes of light reflected on the bay, taken from Corte Madera. 500mm lens, f4 at 1/30, ASA 800, digital camera mounted on a tripod.

102. RUSH HOUR, GOLDEN GATE BRIDGE
Parking behind the toll plaza of the Golden Gate Bridge during morning twilight, one can get a perfect shot of the north- and southbound lanes. The commuter traffic helped me get a stream effect of white and red lights by slowing my shutter speed down and stopping down my lens. 500mm lens, f32 at 1/30 ASA 200, digital camera.

103. CALIFORNIA STREET
A full moon rises directly over the top of Nob Hill at California Street.
500mm lens with 1.4x teleconverter, f5.6 at 1/250 ASA 800, digital camera.

104. FULL MOON, NORTH BEACH
A March full moon shines onto San Francisco's North Beach district. 400mm lens, f4 at 1/60, ASA 800, color negative film.

105. PARTIAL LUNAR ECLIPSE, GOLDEN GATE BRIDGE
Shot under the pressure of daily deadline, this photograph shows a lunar eclipse during moonrise. Initially obscured, the lunar eclipse took about forty-five minutes to appear from the clouds, then suddenly — and briefly — showed itself high above the south tower of the Golden Gate Bridge. 300mm lens, f4 at 1/30, ASA 800, digital camera.

106-107. SUNRISE, ALCATRAZ
A break in the clouds at sunrise sends a shaft of light that reflects upon the bay. 500mm lens, f5.6 at 1/250, ASA 400, digital camera.

108. COIT TOWER
As mapped out by a compass, the sun was going to rise directly behind Coit Tower. The challenge was waking up early enough to walk to mid-span of the Golden Gate Bridge to get this angle. The clouds helped cut down on the sun's brightness as it rose from the eastern horizon. 500mm lens, f/16 at 1/500, ASA 400, digital camera.

109. MORNING, SAN FRANCISCO BAY
The warm morning twilight reflects off a supertanker's bow while another ship approaches.
500mm lens, f8 at 1/250, ASA 400, digital camera.

110. FOG, GOLDEN GATE BRIDGE
All the different elements of this composition came together: fog, city lights, and the twilight. During the holidays, the city buildings are outlined with lights. The South Tower of the Golden Gate Bridge perfectly frames the Transamerica Pyramid from high in the Marin Headlands. 500 mm lens with 1.4x teleconverter, f5.6 at 1/60, ASA 640, digital camera.

111. GOLDEN GATE BRIDGE
Taking a bay cruise around the Golden Gate Bridge allowed me to photograph from a different angle. The day was perfect for tourists, but it was disastrous for any photographers as the sunlight was too hard in the shadows. My only solution was to block the sun with the south tower, which helped cut down on glare. The bay was calm enough to get the sun's rays to dance on the water, but I had to break one of the captain's rules prohibiting me from hanging over the rail. 24-35mm zoom lens, f/11 at 1/500, ASA 200, digital camera.

112. SUNRISE, JACKSON STREET
A cable car makes the crest of Jackson Street during sunrise, just before picking up a passenger.
500mm lens, f5.6 at 1/250, ASA 400, digital camera.

113. SUNRISE, COIT TOWER
From Pacific Heights, I found a vantage point to capture the rising sun silhouetting Coit Tower.
500mm lens with 2x teleconverter, f22 at 1/2000, ASA 400, digital camera.

114. FOG, GOLDEN GATE BRIDGE
Photographers have to believe in luck. One sunrise turned the sky a bright orange, fog shrouded all but the highest buildings, and the Golden Gate Bridge tied all the elements together. All I had to do was press the shutter.
500mm lens, f11 at 1/250, ASA 400, digital camera.

115. SUNSET, GOLDEN GATE BRIDGE
At sunset, the top of south tower of the Golden Gate Bridge is totally engulfed in fog as two seagulls kindly balance out my frame. Photographed from the Marina Green. 500mm lens, f8 at 1/250, ASA 400, digital camera.

116-117. FULL MOON, GOLDEN GATE BRIDGE
A setting full moon passes behind the south tower of the Golden Gate Bridge viewed from Crissy Field in the Presidio.
500mm lens, f5.6 at 1/250, ASA 400, digital camera.

128. BEFORE SUNRISE, BAY BRIDGE
Vividly colored stripes seen from the Marin Headlands show off the iconic Golden Gate Bridge tower.
500mm lens, f4 at 1/125, ASA 640, digital camera.

"San Francisco is a great party town. We may have forgotten everything else, but we can still throw parties, maybe the best in the world. Short days and long nights for dancing till dawn. Then the big hangover, the big depression. The trip to the bridge. The sun is rising out of Contra Costa. The city looks golden, fresh, alluring. What the hell, give it one more day."

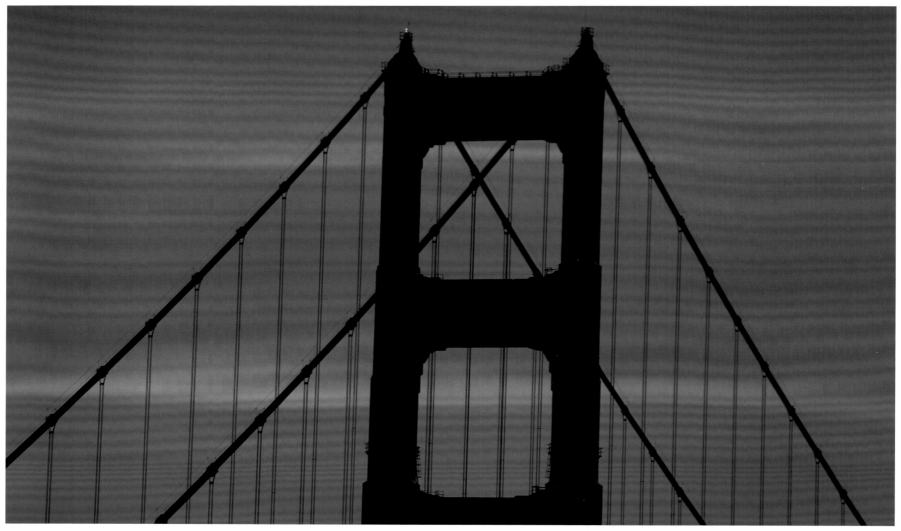

Sunrise, Golden Gate Bridge